PICTURING FLORIDA

FROM THE FIRST COAST TO THE SPACE COAST

KAHREN JONES ARBITMAN SUSAN M. GALLO

PICTURING FLORIDA

Curator, Essay
Kahren Jones Arbitman, Ph.D.

Artist Profiles
Susan M. Gallo

Publisher
Fresco Fine Art Publications, llc
Albuquerque, New Mexico
www.frescobooks.com

Color and Reproduction
Mankus Studios, Santa Fe

Printed in Italy
ISBN 978-1-934491-09-6
Library of Congress Control Number: 2008928111

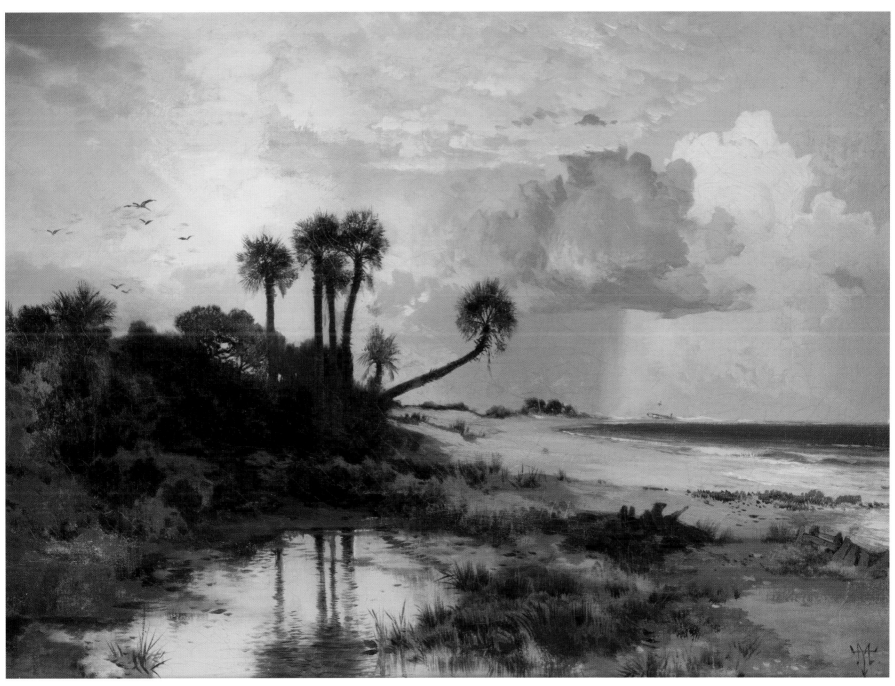

PL. 1

Thomas Moran *Fort George Island,* 1880 Oil on canvas

Sam and Robbie Vickers Florida Collection

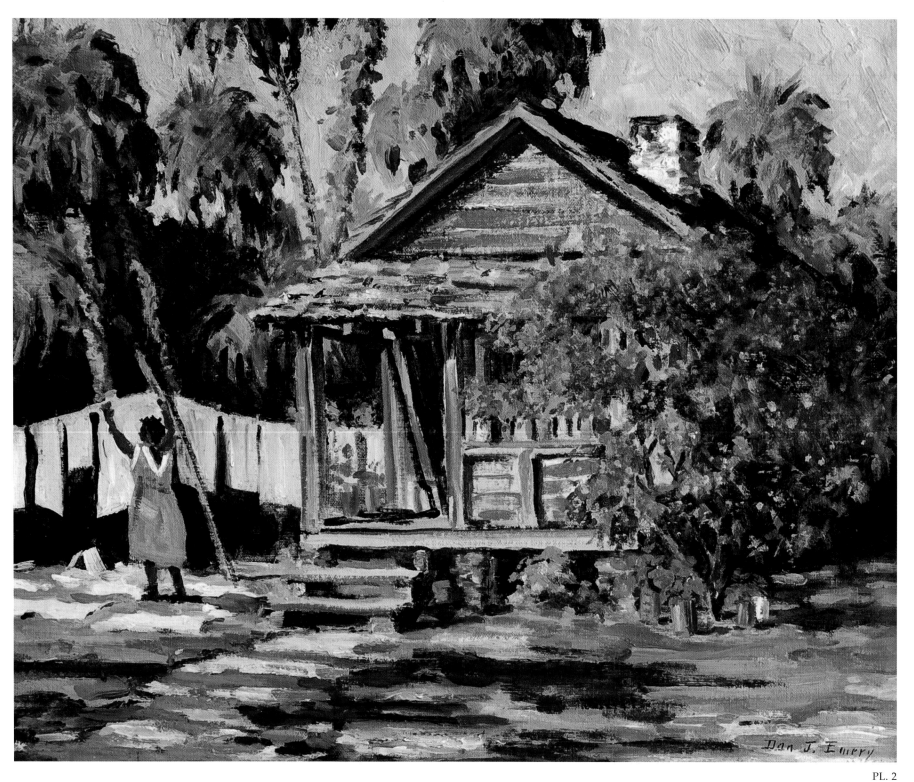

CONTENTS

6 PICTURING FLORIDA

KAHREN JONES ARBITMAN, CURATOR

33 THE ARTISTS

PROFILES: SUSAN M. GALLO

PICTURING FLORIDA

I. PICTURING FLORIDA: JACKSONVILLE TO ORLANDO TO NEW SMYRNA BEACH

La Florida. Juan Ponce de León gave this picturesque title to the verdant coast he encountered on April 2, 1513.[1] Legend has it he was searching for the Fountain of Youth—a quest not unfamiliar to millions of tourists who annually flock to Florida's beaches to "take the waters." In the half millennium since the Spaniard's arrival, some things have remained virtually unchanged: sunrises over intracoastal waterways are still breathtakingly beautiful, dense swamps overhung with Spanish moss still conjure the forest primeval, and many Florida natives are still covered with tattoos. That said, the vast majority of original vistas have been altered beyond recognition.

Five hundred years ago, however, Florida was an untrammeled paradise. Jacques Le Moyne (1533-1588) gets history's nod as the first professional artist to paint *La Florida.* His watercolors of the northeast coast from 1564 would have been lost to the ages had his contemporary Theodor de Bry (1528-1598) not reproduced them in engravings (Fig. 1).[2] These widely-disseminated prints account for the lion's share of visual knowledge of Florida's early appearance. In the centuries since Le Moyne's first images, tens of thousands of artists have painted Florida's topography and inhabitants. With the extraordinary pace of change now affecting the state, many of these artists' images, even those only a few decades old, remain the sole visual record of a quickly vanishing way of life.[3]

While every detail of contemporary Florida is sure to pass to future generations via electronic media, there will always be a special place for "old fashioned" images captured in paintings, prints, sculpture, and photographs. To that end, this volume presents forty artists living in northeast and central Florida who devote most, if not all, of their efforts to picturing the Sunshine State. Those unfamiliar with Florida's geography may wonder why the current book is limited to artists residing in a relatively small triangle of the state, its three corners touching Jacksonville, Orlando, and New Smyrna Beach. The obvious answer lies in the large land area encompassed by Florida's borders. The vicissitudes of history gave Florida 54,000 square miles of land with its northern boundary stretching almost four hundred miles from the Atlantic Ocean to western Alabama and its southern tip lying a scant ninety miles from Cuba (Fig. 2). Thus, a hardy soul wishing to undertake a car trip from Key West to Pensacola would find himself still short of his goal at the end of a long day's drive. This physical reality quickly ended all thought of reviewing art from the entire state.

There exists, perhaps, an even more cogent reason for limiting the area included in this book. The long distances separating one end of Florida from another have produced distinct regional subcultures—so disparate that the aggregate has been called, "a collection of cities in search of a state."[4] Counties bordering Georgia and Alabama have close cultural ties to their neighboring states, while South Florida and the Keys tend to reflect their physical proximity to Cuba and the Caribbean Islands. These are gross generalizations to be sure, but travelers to Miami and Pensacola would find discernibly different cultures expressed in everything from ethnic mix, accents, political persuasion, food,

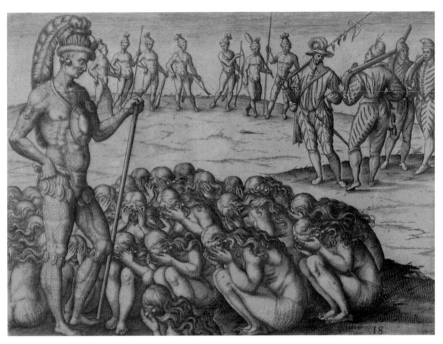

Fig. 1 Theodor de Bry after Jacques Le Moyne
The Chief Applied to by Women Whose Husbands Died in the War or by Disease, 1591
Engraving The Michael and Linda Fisher Collection

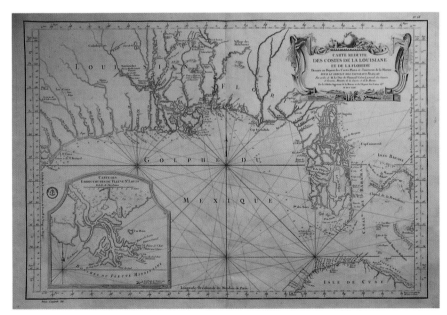

Fig. 2 *Carte Reduite des Costes de la Lousiane et de la Floride*, 1764
Engraving The Michael and Linda Fisher Collection

architecture, and, because art mirrors society, the style of local art. This carries over to the art markets. "Art Basel Miami Beach," the annual extravaganza of international contemporary art, is very much at home in this cosmopolitan city, while quaint galleries brimming with paintings of local sites sit comfortably along St. Augustine's cobbled alleyways. And what local art markets will support—from cutting edge to a more homespun variety—can be a major influence on what is locally produced. Thus, the notion of "Florida Art" depends on where in Florida you are: in Miami art is *hot*, in Key West it's *cool*, and in Panama City it's *laid back*—way back. Expand the list to include all of Florida's cities, towns, and villages and the stylistic possibilities expand beyond measure.

Even within the small geographic "triangle" encompassed by this volume, where every artist lives no more than two and a half hours by car from every other artist, no single style describes even a small fraction of their work. Some of the diversity can be ascribed to the relative size of the communities. Big cities with large cultural infrastructures like Jacksonville and Orlando attract, promote, and support a wide range of artists. College towns like DeLand and Winter Park offer their own intellectual and creative benefits, but with less opportunity for exposure to a wide art market. And then there is the phenomenon of the seaside towns of St. Augustine and New Smyrna Beach. Quite distinct from one another, both are nationally prominent for fostering the visual arts.[5] Yet even within these small artistic communities, wide stylistic swings exist.

And therein lies the challenge of assembling a book of forty artists whose only certain commonality is the state in which they live. Of these artists, all of whom now reside in northeast or central Florida, less than a third began there. Some were attracted to the area by the artistic possibilities inherent in the local topography, others by the idea of joining established art communities. Many more, however, were lured by job opportunities and the promise of permanently getting out of the cold. But whatever brought them to the state, these Florida artists are the product of educational and artistic influences garnered from throughout the country, and even throughout the world. Once established in Florida, these painters, sculptors, printmakers, and photographers grafted their styles onto the local topography to create art that captures and defines this small slice of paradise.

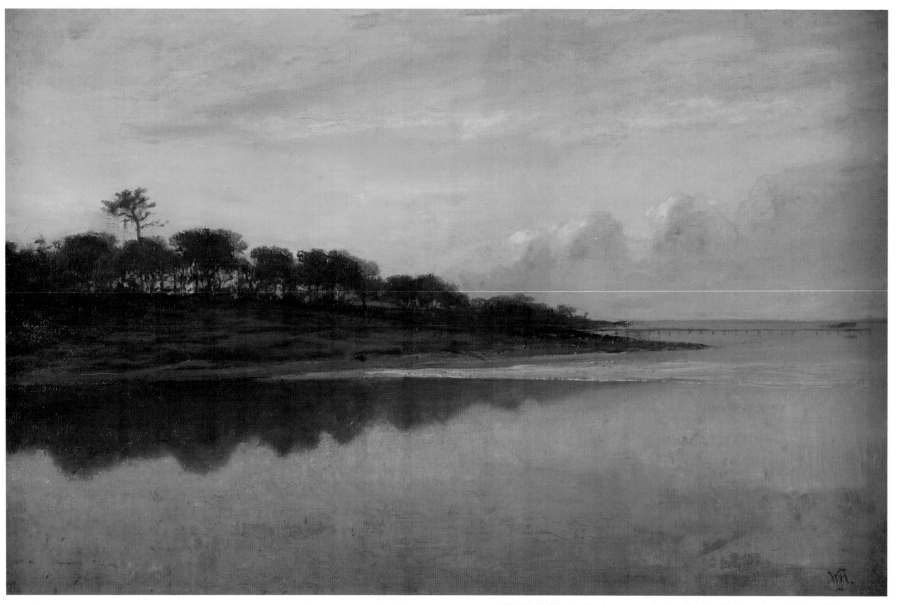

Fig. 3 William Morris Hunt *View of the St. Johns River,* 1874 Oil on canvas
Sam and Robbie Vickers Florida Collection

II. PICTURING FLORIDA BEFORE 1900

Florida became the country's twenty-seventh state in 1845. This seems particularly late in the game considering that St. Augustine was settled in 1565—fifty-five years before the Pilgrims' purported landing in Plymouth. But history, both natural and political, conspired against *La Florida* to slow her progress. With a total population in 1845 hovering at 70,000, most of it agrarian and forty percent of it enslaved,[6] it is not surprising that homegrown professional artists were few and far between. In fact, for most of Florida's early history the vast majority of artists who visually recorded the territory resided elsewhere. Some of the first artists were relatively unknown cartographers and topographers who came to map the land, while a few were noted naturalists, such as William Bartram (1739-1823) and John James Audubon (1785-1851), who made the journey to catalogue the exotic flora and fauna.[7] By mid-nineteenth century, Florida's equally exotic inhabitants, the Seminoles, drew noted Indian painters such as George Catlin (1794-1872) to the state. And, as in every era, military conflicts lured their own cohort of artist-journalists.[8]

It was only after Reconstruction that significant numbers of artists traveled to Florida without pre-set artistic missions. Their motivations mirror those of visitors described in 1875 as either needing a cure from "general debility or mental or physical prostration" or if healthy, coming "to gratify their curiosity about the country, or because they do not enjoy the northern winters; a few came on business."[9] Such were the reasons that a number of notable artists visited northeast Florida in the last quarter of the nineteenth century. More often than not, their destination was Jacksonville, the east coast terminus for the mainline railroad and most ocean steamers.[10]

The Boston painter William Morris Hunt (1824-1879), for example, journeyed to Jacksonville in 1873 to allay his depression caused by a devastating studio fire that destroyed much of his art and, along with it, his marriage.[11] He was the guest of railroad magnate John Murray Forbes who had invited the distraught artist to sunny Florida to recuperate. The change of scenery and climate worked wonders. Heretofore, Hunt's work consisted mainly of portraits, but the quiet calm of Florida's expansive vistas turned his attention to landscape painting. The spectacular St. Johns River, well over two miles wide as it meanders northward through Jacksonville, was a particular attraction. Broadly painted in warm, sun-tinged colors, Hunt's *View of the St. Johns River* (Fig. 3) evokes solitude but not sadness. The painting's rich, natural beauty holds melancholy at bay.

Four years later Thomas Moran (1837-1926) made the trip from Philadelphia. Moran, who had achieved early artistic success as a magazine illustrator, traveled to Jacksonville at the behest of *Scribner's Monthly* to create images for an article on nearby Fort George Island.[12] Although the magazine illustrations produced from Moran's on-site drawings are proficient, they are eclipsed by his painted reflections of the same terrain. Moran's painting *Fort George Island* is indisputably his finest Florida landscape (PL. 1).[13] Moran infused the small canvas with his complete sensory response to the topography he encountered at Florida's edge. As a blazing sunset streaks the sky silhouetting subtropical vegetation against its molten colors, the spindly palm trees splinter into black dashes and daubs as they reflect in a pool left behind by the retreating tide. A thunderous, backlit cloud adds to the pictorial drama.

Winslow Homer (1836-1910), whose home was Prout's Neck, Maine, was "lured" to the Sunshine State by its legendary fishing. Beginning in 1885 and continuing for almost a quarter century, the renowned artist and sport fisherman traveled to Florida to cast his line in local waterways.[14] His watercolors and brushes were always close at hand. Initially Homer's Florida scenes focused on sporting activities with large-scale figures. Ever the businessman, he quickly recognized that cold, big-city Northerners preferred painted vistas of warm, largely uninhabited locales—places where hectic life yielded to leisurely

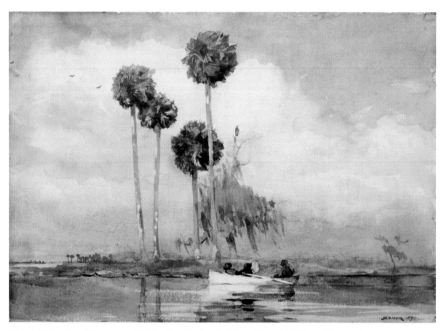

Fig. 4 Winslow Homer *White Rowboat, St. Johns River,* 1890 Watercolor on paper
Bequest of Ninah M. H. Cummer, C.0.154.1
Cummer Museum of Art & Gardens, Jacksonville, Florida

pleasures.[15] By the time Homer painted *White Rowboat, St. Johns River* while visiting Jacksonville in 1890, unspoiled nature had taken center stage (Fig. 4).[16] As a mist settles over the river and palm fronds rustle on precariously thin stalks, a small rowboat skims the water, its white form and three inhabitants seeming to dissolve in the atmosphere. Unfortunately for the history of Florida art, these picturesque vistas that provided Homer and other artists with great material were not enough to make them stay. Their lives lay elsewhere and by spring they were on their way home.

While Jacksonville was the final destination for most Florida-bound passengers, a few more-adventuresome travelers transferred to small-gauge railroads and river boats for locales farther south, quite often St. Augustine.[17] Among these winter vacationers—first called "strangers," then "visitors," and finally "tourists"[18]—were artists looking to paint local vistas and historical sites as souvenirs for this ready market. It was a fairly fledgling business, however, until Henry Morrison Flagler came to town. His decision in 1885 to erect an extraordinary resort hotel in St. Augustine and simultaneously to improve rail transportation between Jacksonville and the tiny coastal community had

far-reaching consequences for every aspect of life in northeast Florida, including the visual arts.

It is an oft-told story. Flagler, co-owner of Standard Oil, and his new bride traveled to St. Augustine in 1883—population 2,000—for their honeymoon. They found St. Augustine charming. Returning two years later, they were smitten once more by the town but were most unhappy with both the transportation and the accommodations. Flagler decided to vastly improve both; the results were the Florida East Coast Railway[19] and the Hotel Ponce de Leon. No expense was spared for this Mediterranean-style resort intended for the country's elite. On January 10, 1888 the lavish 540-room hotel opened and America's aristocracy poured in.

Coincidentally, Martin Johnson Heade (1819-1904), whose 1883 arrival in St. Augustine corresponded with Flagler's honeymoon, would become the first prominent artist to move permanently to Florida.[20] Although the oil magnate would number among Heade's best patrons, the artist had established a local reputation long before the first spade of dirt was turned for Flagler's hotel. As early as 1884 Heade's cottage had become the locus where society gathered to admire art and engage in polite conversation.[21] But Heade was ambitious, and perhaps it was he who convinced Flagler to include an annex within the hotel complex with studio space for artists. For years thereafter, the most prominent studio belonged to Heade.[22] The painting *St. Johns River* (Fig. 5) with its long, low horizon and softly veiled light is characteristic of Heade's landscapes painted during his years spent in courtly splendor at Flagler's pleasure palace.[23]

Flagler's impact on Florida art did not stop in St. Augustine. Every time he pushed his Florida East Coast Railroad farther south, prosperity was aboard. From this prosperity grew communities that eventually would be large enough to support the arts. In 1886 Flagler's train pulled into Ormond Beach, by 1889 it had reached Daytona Beach.[24] New Smyrna Beach, eleven miles to the south, was three years behind.[25] That same year, 1892, Flagler discovered a "veritable Paradise" in Palm Beach.[26] His decision to build the "largest hotel in the world" in this heretofore unknown village and to bring the railway to its door would have direct consequences for the Florida communities to the north. Not unexpectedly, the wealthiest vacationers began to abandon St. Augustine and other small beach towns for Flagler's latest wonder. Along with them trailed the fair-weather artists.

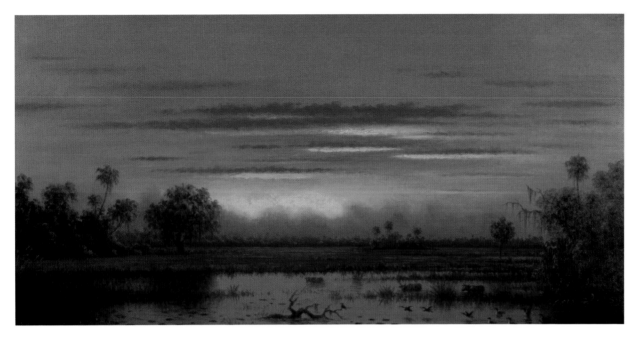

Fig. 5 Martin Johnson Heade
St. Johns River, c.1890s Oil on canvas
Museum Purchase with Membership
Contributions, AP.1966.29.1
Cummer Museum of Art & Gardens,
Jacksonville, Florida

But left in Flagler's wake were foundations that allowed Florida's northern coastal communities to grow. They had the train, the tourists, the money, and eventually, the art. But what was happening away from the coast in central Florida? A look at the numbers supplies an easy answer. In 1900 Jacksonville's population totaled 28,429, the largest in the state; St. Augustine was one-seventh its size with 4,272 inhabitants. And Orlando? The town could muster only 2,481 permanent residents for the census.[27] If artists numbered among them, they did not leave much of a trace.

Surprisingly, the first central Florida town that can definitely claim resident artists was not Orlando, but its then-tiny northeastern neighbor Winter Park.[28] In 1885 the town fathers won the competition for the site of a liberal arts college proposed by the Congregational Church. Alonzo Rollins, who pledged the most money, was rewarded with the college's name. From the beginning, Rollins College had art faculty. Lizzie Hatch held the position of Teacher of Art from 1885-1886 followed in 1886 by Alice Ellen Guild (1860-1949).[29] An 1883 graduate of Massachusetts Normal Art School, Guild gave up her ambition to open an art studio in Boston to follow her family to Winter Park.[30] By 1897 she was director of the School of Art, a position she held until 1905. A number of Guild's Florida watercolors, pencil sketches, and figure studies remain in the Rollins archives.

That Rollins College had an art department from its earliest days is notable; that it was not alone in central Florida is truly remarkable. In 1876 the area now known as DeLand was largely uninhabited when Henry Addison DeLand founded the town. A scant eleven years later, John B. Stetson University (now Stetson University) began undergraduate classes.[31] Art was always part of the curriculum. Miss Annie K. Tuthill was principal of the Art Department until 1888.[32] William Alexander Sharp (1864-1944) joined the faculty in 1894. Sharp was a painter, printmaker, muralist and stained glass designer whose 1897 chapel windows representing Stetson's motto *Pro Deo et Veritate* remain in place in Elizabeth Hall.[33]

These college art teachers aside, as northeast and central Florida turned the corner on the twentieth century, resident artists were rare. But the population was growing, the developers were out in full, and more and more visual artists were beginning to think that there might be a home for them in the Sunshine State.

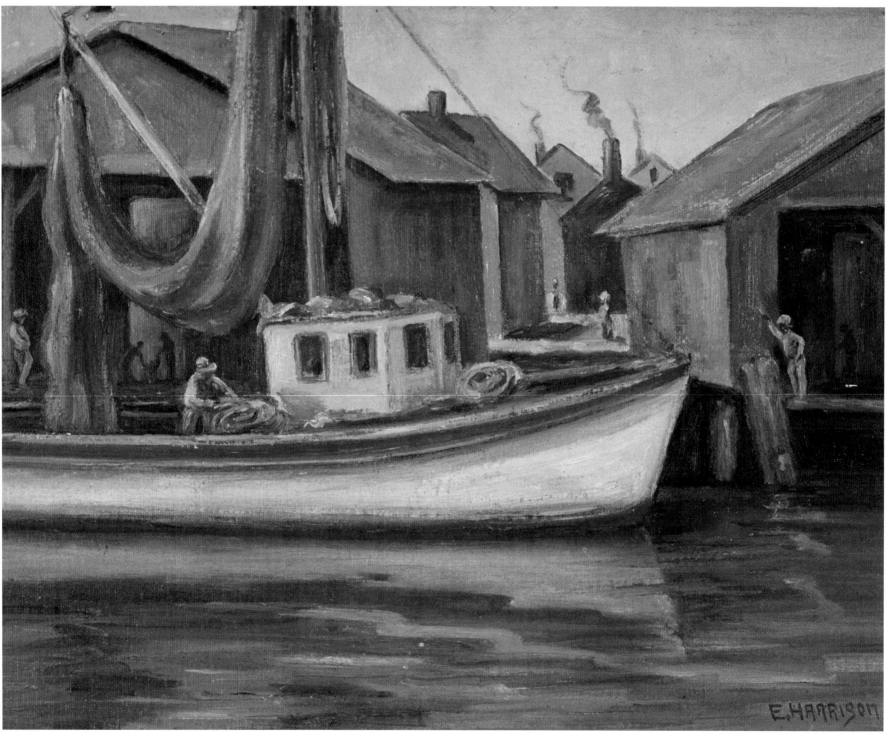

Fig. 6 Edith Smith Harrison *Boat Scene in Jacksonville* Oil on board
Sam and Robbie Vickers Florida Collection

III. PICTURING FLORIDA 1900 – 1945

While state historians are quick to point out that Florida was thriving long before the advent of air conditioning and DDT, the fact remains that these World War II innovations made life in the state not just bearable, but actually desirable. The resulting post-war population explosion catapulted Florida from twentieth in state population in 1950 to fourth in 1990 behind California, New York, and Texas.[34] Sweeping in with the tide of humanity were vast numbers of permanent-resident artists. It is worth noting, however, that long before the existence of a population base large enough to truly support the visual arts, a number of stalwart artists began moving their studios to northeast and central Florida. The idea of living in sunshine seems to have trumped both the bugs and the heat.

Throughout Florida, whenever artists found themselves living in the same community they often banded together for mutual support and promotion. Out of this natural camaraderie grew the all-important local art associations. The existence of these associations verifies the presence of a significant number of local artists. The Fine Arts Society of Jacksonville, founded in 1924, is a case in point. Begun as equal parts social club and art association, the society's president was Mayor John T. Alsop, known for enthusiastically promoting anything that brought tourists to town. Given his inclinations, it is not surprising that the mayor presided at the opening of the society's first exhibition in 1928; he even donated a cash prize.[35]

Even before the Fine Arts Society began to organize local artists, two Jacksonville artists with impressive credentials, Louese Bunnell Washburn (1875-1957) and Edith Smith Harrison (b. 1879), were successfully exhibiting in Florida.[36] Harrison's *Boat Scene in Jacksonville* (Fig. 6) with its crowded buildings, work boat, and fishermen suggests that Miss Harrison was no shrinking violet confined to rose gardens and tea parties, but rather a stalwart artist who could set off at dawn for a firsthand look at life on the docks.

In addition to Harrison, Jacksonville artists Myrtle A. Reeves and Walter de Wolfe were winning notice for their paintings in Florida and other southern states. About 1927 Reeves and de Wolf were described as co-directors of the Art School of Jacksonville.[37] In 1930 Harold Hilton is recorded as directing the "Jacksonville Art Academy" which probably was the same institution. Having come from Chicago around 1925, Hilton had a reputation for high quality water-colors depicting Florida locales.[38] In fact, from their titles it appears that the majority of works exhibited by Jacksonville artists carried Florida themes.

The early 1920s saw the founding of art associations in other growing Florida towns as well. Almost from the beginning, local clubs recognized the advantages of banding together into a statewide organization. In April 1927 fifty delegates from throughout Florida met in Orlando to form the Florida Federation of Art. An important organizational goal was to present annual exhibitions and conventions at various member locations.[39] In 1931 the federation held its annual exhibition in the galleries of the Jacksonville Chamber of Commerce Building.[40] The same year Jacksonville hosted the federation's fourth annual convention. Delegates reporting on the convention damned with faint praise the availability of fine art in the city: "Jacksonville has no art gallery; it has art treasures, but privately owned. Art is a department in the public schools, but only in the grades, and elemental as yet. There is room here for greater consideration of the fine arts."[41] Unfortunately, the Depression put an end to any thought of immediate improvement. In fact local artists were particularly hard hit when tourists stayed home and the natural art market dried up.

One undaunted artist who arrived in Jacksonville just as the markets crashed was Memphis Wood (1902-1989). Born in Georgia, Wood came south to study at the University of Florida in Gainesville. In 1929 having received her MFA from the University of Georgia, she moved permanently to Jacksonville. For the next

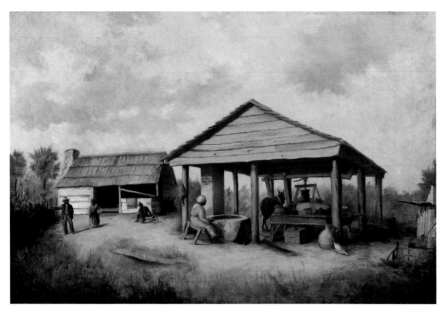

Fig. 7 Memphis Wood *Grinding Sugar Cane*, 1939 Oil on canvas
Morton R. Hirschberg Memorial Fund purchase, AP.2005.2.1
Cummer Museum of Art & Gardens, Jacksonville, Florida

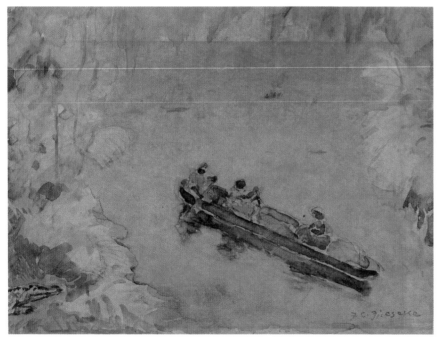

Fig. 8 Frederick Carl Frieseke *The Pirogue (Canoeing, Florida)*, 1921
Watercolor on paper Purchased with funds provided by the Schultz Endowment,
the Childress Endowment and the Kenneth G. Lancaster Restricted Fund, AP.2001.1.13
Cummer Museum of Art & Gardens, Jacksonville, Florida

sixty years, Wood worked passionately for the city's cultural advancement by teaching generations of art students. Recognized today for her abstract art, earlier in her career Wood favored a realistic, regional style. Her painting *Grinding Sugar Cane* from 1939 shows black workers tending various stages of sugar production (Fig. 7). Regardless of whether the locale depicts Wood's native Georgia or adopted home of Florida, both of which processed large amounts of sugar cane,[42] the artist wraps the hard labor of southern blacks in a golden glow of nostalgia.

By 1936 the Fine Arts Society of Jacksonville sought to strengthen its position by merging with the Civic Art Institute, a WPA program that sponsored community art centers.[43] The local institute's 1940 progress report lauds its "four years of continuous effort that has resulted in a dynamic program of community art." Classes, exhibitions, education, outreach, and an art library were all part of the "experimental art center," located, it seems, on West Duval Street. The group's ultimate goal, stated in capital letters on page one of the report, was to establish a permanent art center for Jacksonville. The war would put this goal on hold.

It should be mentioned that Jacksonville was indeed home to a nationally known twentieth-century artist, Augusta Savage (1892-1962), but she achieved acclaim elsewhere. This famous Harlem Renaissance sculptor was born and raised in Green Cove Springs, a small town fifteen miles south of Jacksonville. Although she spent her early adulthood in West Palm Beach, she returned to Jacksonville's thriving African American community to pursue a professional career sculpting portraits of local personalities. Stymied by the lack of opportunity, she left for New York in 1921 where her career blossomed.[44] But Savage never completely severed her ties to Jacksonville; in 1939 she sculpted a bust of one of the city's most famous sons, James Weldon Johnson, the poet and songwriter whose poem *Lift Ev'ry Voice and Sing* became the Negro National Anthem.

Like Augusta Savage, artist Frederick Carl Frieseke (1874-1939) lived his early years in Jacksonville only to claim international fame elsewhere. But Frieseke's Huck Finn childhood spent along the St. Johns River was etched in his memory. In 1921 the painter drew upon these recollections to create a series of beguiling images of life along Jacksonville's waterways before progress took over.[45] His watercolor *The Pirogue (Canoeing, Florida)* is a lively concoction of river travel that includes hand-, wind-, and steam-powered vessels. Within the delicate foliated framework, an alligator keenly eyes the boaters paddling by (Fig. 8).

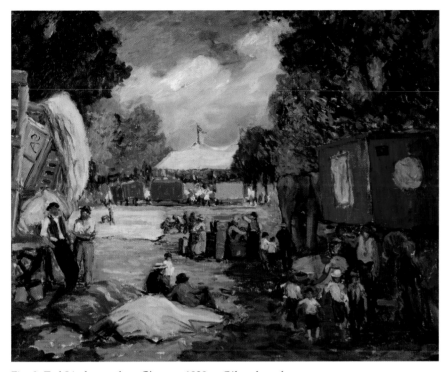

Fig. 9 Tod Lindenmuth *Circus*, c.1930 Oil on board
Sam and Robbie Vickers Florida Collection

Coincidentally, the same year that Jacksonville founded its art association, a similar group was forming in St. Augustine. The Pen and Brush Club began in 1924 as a collegial forum for artists and writers. By 1931 it had evolved into the St. Augustine Arts Club.[46] This name change accompanied a significant change in organization. The new club's charter members recognized that they could help themselves by promoting their town as an artists' community. In exchange for use of a city building, the club agreed to work toward creating a substantial winter art colony in St. Augustine. In thanking the city for granting the requested space, club president Ralph H. Hillbom noted, "New England has had heretofore almost a monopoly of the artists who literally swarm there in the summer months They are to be counted in the hundreds of thousands. We must attract our share of them to the state and to St. Augustine."[47]

In 1934 the organization incorporated under the name Arts Club of St. Augustine. At the height of the tourist season in 1939, two hundred artists were counted in town; the publicity campaign dually waged by the club and city was

working.[48] Additionally, Hillbom's earlier prediction was on the mark: professional artists who summered in northern art colonies could be lured to St. Augustine for the winter. A large number came from Provincetown, Massachusetts. Among the first was the artist couple Tod Lindenmuth (1885-1976) and Elizabeth Boardman Warren (1886-1980) who visited St. Augustine in 1934 and became permanent residents in 1940.[49] As soon as they reached St. Augustine each year, local activities and landmarks made their way back into the couple's work. Lindenmuth's painting *Circus*, for example, uses lush brushstrokes and vibrant colors to capture the excitement and anticipation that swirled around these touring companies as they rolled into town (Fig. 9). Other noted members of the Provincetown Art Association who followed the Lindenmuths to St. Augustine included Jacksonville native William Johnson L'Engle, Jr. (1884-1957) and his wife Lucy Brown L'Engle (1889-1978). Blanche Lazzell (1878-1956) who had deep ties with the Provincetown art community was another early modernist who traveled to St. Augustine as soon as cold weather hit the Cape.[50]

As the 1920s progressed, artists continued to set up studios farther down the east coast. Invariably these artists befriended one another and fledgling art clubs took shape. Around 1927, a group of Daytona Beach artists began to paint outdoors in Mrs. E. L. King's garden at get-togethers called "picnics."[51] Many of the picnickers were students of artist Don J. Emery (1888-1955) who had moved to the area in 1922. By 1932 the informal group had grown large enough for Emery and his friend John Rogers to organize a formal art club. Forty-five artists participated in the club's first group show. Energized by the exhibition's success, the artists formed the Daytona Art League on May 28, 1932. Its two founding fathers were high-profile community members. Rogers was an architect, printmaker, painter, and son of one of the founders of the Art Institute of Chicago. Emery was a passionate proponent of art and life who was one of Daytona's most beloved and admired residents.[52] *Wash Day at Freedmanville/Port Orange, Florida* is one of a pair of Emery paintings from the 1930s depicting the area that was once home to over a thousand freed slaves who worked for the Florida Land and Lumber Company (PL. 2).[53]

When Emery died in 1956, artist Fred Dana Marsh (1872-1961) wrote touchingly of his friend, "To Daytona Beach when it was a struggling community, too busy in its effort to battle unruly living conditions to have achieved spiritual development, he came; a noble generous man to infuse beauty through painting and

make our townfolk conscious of the wonderful pictorial richness of their community"[54] Marsh, a well-known painter, printmaker, and muralist, could have been describing his own efforts to introduce beauty into nearby Ormond Beach. The father of famed artist Reginald Marsh, the elder Marsh came to Ormond in 1928. Soon thereafter, he purchased oceanfront property on which he and his wife Mabel van Alstyne built an idiosyncratic home they named "The Battleship."[55] Besides painted skeletons in the closet and carrousel horses along the seawall, it was decorated with Marsh's stylized sculptures depicting Florida's first people, the Timucuans.[56] Marsh also created a monumental outdoor sculpture entitled *The Legend of Tomokie* at the tip of the narrow peninsula bordered by the Halifax and Tomoka Rivers. Inspired by Marie E. Mann Boyd's writings on the "Fountain of Youth," Marsh believed these local mythologies could be used to entice and enthrall tourists in much the same way that the legends of Rip van Winkle and Ichabod Crane promoted the mystery of the Hudson River Valley.[57]

While artists in towns along Florida's east coast were mobilizing, their colleagues in central Florida were doing the same. From existing records it appears that Orlando's artists, once they came together, organized themselves rather quickly. On January 16, 1924, Ruby Warren Newby and Lu Halstead Jerome assembled twenty-five interested people in the city's Albertson Public Library. Out of this single meeting emerged the Orlando Art Association. Only a month later on February 16 the bylaws and constitution were adopted with the stated purpose "to encourage and promote art and its appreciation throughout Central Florida by all practical means." Fifty charter members signed on. A local newspaper described the group in glowing terms, "The Orlando organization is altogether altruistic. It has no commercial leanings, no profit-making angles, nothing except a purpose to bring together those who believe that art may be made a great force in the spiritual encouragement and uplift of the individual as well as the community."[58]

The association's early exhibitions featured a mix of local artists and visiting artists in town "for the season." Honor of the first exhibition went to Edith Fairfax Davenport (1880-1957). A third cousin of James McNeill Whistler and the first woman admitted to the École des Beaux Arts in Paris, Davenport maintained a studio at the home she inherited from her father in Zellwood, Florida. Among her local paintings were a series of murals in the Orlando Chamber of Commerce Building representing Florida's industries: citrus, lumber, cattle, and

turpentine.[59] A 1931 newspaper article proudly describes the cosmopolitan artist's local ties: "Miss Davenport spends time in New York and elsewhere, but calls Orange County home."[60] The same year association officers were atwitter at successfully securing an exhibition of ten Florida paintings by George Inness, Jr. (1854-1926). Other early exhibitors included Frank French, (1850-1933), who for several years in the late 1920s "passed the winter season in Orlando making oil paintings."[61] During one visit French completed a portrait of library patron Captain Charles L. Albertson that still hangs in the Orlando Public Library. French so charmed the association's members that they elected him an honorary member in 1929.

With local newspaper articles gushing over every association activity, including the color of table bouquets, the Orlando Art Association quickly became the focus of cultural life in central Florida. In only two years the association was ready to incorporate. By 1927 it outgrew its original space in the library and moved to the Lake Ivanhoe Chamber of Commerce Building. Member lists for 1928 included 118 names; the number would soon expand to over two hundred. By 1929 association members were already talking of an art museum for the city, but this dream would take decades to realize.

Other central Florida towns were equally engaged in fostering the visual arts. As it had since the turn of the century, Rollins College in nearby Winter Park continued its leadership role. Except for a two-year hiatus after World War I, classes taught by professional artists were always part of the college's curriculum. Hamilton Holt, Rollins' internationally-renowned president from 1925 to 1949, was personally involved in securing important artists for the art faculty. It was Holt who initially lured Frank French to central Florida in 1927 with the offer of a special lecturer position.

Constance Ortmayer (1902-1988) was a particularly impressive Holt appointee. A graduate of the Akademie der bildenden Künste in Vienna, Ortmayer was hired to teach "the plastic arts." She began as Rollins instructor in 1937 and retired three decades later as Professor of Sculpture and Chairman of the Department of Art.[62] Ortmayer's many notable commissions included the 1936 medal for the Florida Academy of Sciences.[63] In 1938 Ortmayer won a federal commission to decorate the public library in Arcadia, Florida.[64] While at the college she also sculpted a number of portrait medals of Rollins College presidents including George Morgan Ward, William Fremont Blackman, and

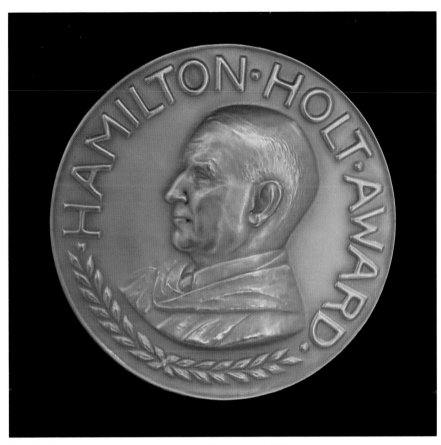

Fig. 10 Constance Ortmayer *Hamilton Holt Award*, 1956 Bronze
Rollins College Archives and Special Collections, Winter Park, Florida

Hamilton Holt (Fig. 10). The latter medal, which can be awarded to the "famous or the unknown," is reserved for "those who have in some way shown that any man, anywhere, guided by truth and armed with honesty, can find his own true destiny."[65]

No art faculty addition would prove more momentous for Rollins College and Winter Park than the appointment of Hugh Ferguson McKean (1908-1989) to instructor in 1932. Only a year after graduating from Rollins in 1930, McKean was making a name for himself. A local newspaper reported that "young" Hugh McKean's portrait of his brother Vance won first prize in the Florida Federation of Art show in Jacksonville, despite competition from "some fifty other artists,

many of whom are recognized nationally."[66] McKean's academic rank at Rollins rose rapidly: assistant professor in 1935, associate professor in 1941, professor in 1945. Even more notable was his 1951 appointment to college president, a position he held until his retirement in 1969.[67] Over the years McKean and artist Jeannette Genius (1909-1989), whom he married in 1945, would become the driving force behind visual arts in Winter Park.

Even as young artists, McKean and Genius understood the value of getting their art before the public. In January 1938, probably aided by Jeannette's family fortune, a group of seven local artists opened the Winter Park Gallery on Welbourne Avenue. Applauding their effort in a review of the gallery's opening, Constance Ortmayer observed, "Local talent should be fostered where it appears, not sent off . . . to great cities where usually the young artist loses not only hope and courage but often his own identity."[68]

Four years later Genius funded an art gallery as part of a new Rollins art complex. The Morse Gallery of Art, which opened February 17, 1942, was named for Genius' grandfather Charles Hosmer Morse, longtime trustee and generous benefactor of the college. Hugh McKean became the gallery's first director. Setting the tone for the wide-ranging exhibitions that would follow, the gallery's inaugural exhibition featured paintings and sculpture from Costa Rica followed the next month by Latin American art from pre-Columbian to modern.[69]

Like Rollins, Stetson University in DeLand sought out distinguished artists for its faculty. Harry Davis Fluhart taught at the university from 1914-1935. Now largely unknown, Fluhart was described by Stetson colleague Warren Gordis as an "outstanding figure in our art department." Goris added, "It is no exaggeration to say that he was a great artist."[70] Around 1914 Fluhart transformed the north wing of Elizabeth Hall into an art gallery and hung it with his paintings.[71] Sculptor George Étienne Ganière (1865-1935) also is recorded as teaching at both Rollins and Stetson. Characterized in an Orlando newspaper article as the "Official sculptor of the state of Florida," Ganière established his reputation creating images of Abraham Lincoln. The article continues that after retiring as head of the Art Institute of Chicago he spent winters at his estate at Glenwood near DeLand.[72]

In the 1930s, the central Florida town of Maitland unwittingly found itself on the artistic cutting edge when Jules André Smith (1880-1959) came to town.

Smith, an architect, painter, printmaker, and set designer, bought property near Lake Lily, built a studio, and settled into life as a local eccentric and curmudgeon. His verbal darts targeted local art lovers who were slow to embrace "modern" art. Assisting in maintaining the old order were artists such as Carle Blenner, described as a "famed exponent of the conservative school," who lectured in nearby Winter Park in early January 1935. He announced to his audience, "I have seen these modernist movements come and go. . . . Picasso and all the modern school are losing ground rapidly Meanwhile the more conservative work continues to live."[73] The gauntlet was thrown. Less than two months later Smith used the occasion of the closing of a traveling exhibition of Italian Renaissance paintings to opine in the weekly newsletter *Winter Park Topics*: "The total so-called art patrons around here . . . are divided into two classes: those who are beginning to live and those who are beginning to die. To the latter class the Old Stuff appeals strongly for the simple reason that the New is no longer within their reach." Smith's hilarious diatribe ends by calling for more modern art exhibitions.[74] For weeks thereafter heated rebuttals crammed the same newsletter, one of which began, "We who are about to die salute you."[75]

Too impatient to wait for others to bring contemporary art to central Florida, Smith began building an "intimate" gallery next to his studio to exhibit work of young—and presumably modern—American artists.[76] The completion of the "Paintbox Gallery" made front-page news as community members waited to see what Smith would bring to town.[77] Soon thereafter, Smith's modest plans expanded beyond measure when Mary Curtis Bok took up his cause.[78] Mrs. Bok, a forward-thinking philanthropist, agreed to fund a "laboratory" for research in modern art. Mrs. Bok never did anything small; by January 1937 the project had expanded to include a building complex with studios, exhibition galleries, and living quarters for visiting artists. Named the Research Studio, its mission was to serve as a "testing ground for such ideas in methods and mediums of creative expression that may come to its notice for experimentation or development."[79] On January 6, 1938 the Research Studio opened its doors to the first class of visiting artists. Over the next twenty years, such notable artists as Ralston Crawford, Milton Avery, Arnold Blanch, and Doris Lee ventured into Smith's "Utopia" and were given "the opportunity to join in the spirit of exalted exploration out of which can emerge new visions and new and stimulating ways of recording them."[80]

During the Research Studio's winter season of 1940, Smith exhibited over thirty of his own watercolors and paintings with the title "Florida Byways." Painted over eight years, the series is described by a local reviewer as, "the real Florida of happy poverty and sandy roads which the golf-playing tourist seldom sees."[81] A poem Smith wrote for the exhibition makes the same critical observation: winter visitors see only the "dressy" side of Florida. For Smith, true Florida is found instead in "lowly habitations," because as he ends his verse, "these humble, mellow dwellings are native-born by men who love the earth."[82] Among Smith's "mellow dwellings" are the African American churches that dot central Florida. In Smith's *Church Scene, Eatonville*, for example, the steepled, clapboard building stands nobly in the pines (Fig. 11). Here in bright colors and broad strokes, Smith captures the vibrancy of Maitland's neighbor Eatonville— the first all-black town to be incorporated in the United States and the childhood home of nationally acclaimed author and folklorist Zora Neale Hurston.

From artists like Smith who lobbied for "modern" art to those who championed a more traditional approach, by 1940 Florida artists from Jacksonville to Orlando to New Smyrna Beach were a vital force in the life of their communities. Art associations throughout the area were aggressively pushing for more classes and exhibitions. In Orlando and Jacksonville the foundations of what ultimately would become art museums were in place. Colleges were offering degrees in fine arts. In ways both small and large, art was finding its way to *La Florida*. As it did in every part of the country, World War II irrevocably altered the status quo in Florida and ushered in a new reality. And as they did in every other state, Florida's artists responded with creativity and flair.

Fig. 11 Jules André Smith *Church Scene, Eatonville,* c. 1940 Oil on masonite
Maitland Art Center, Maitland, Florida

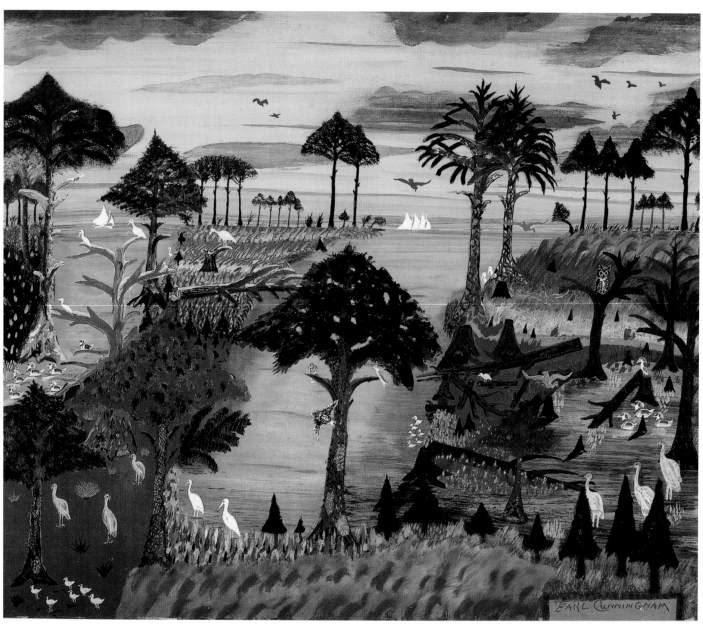

Fig. 12 Earl Cunningham *Sanctuary,* 1933 Oil on board
Gift of The Honorable Marilyn L. Mennello and Michael A. Mennello
Mennello Museum of American Art, Orlando, Florida

IV. PICTURING FLORIDA: POST WAR TO THE NEW MILLENNIUM

Authors writing the history of Florida art tend to end their surveys at 1945. Thereafter the number of permanent-resident artists grew so quickly that categorizing them was a task for another day. While it is beyond the scope of this essay to fill the gap, some mention should be made of the associations, educational institutions, and exhibition venues that nourished northeast and central Florida artists in more recent times.[83]

One telling shift in statewide dynamics was the incorporation of the Florida Artist Group (FLAG) in 1949. FLAG differed significantly from the Florida Federation of Art by representing individual artists rather than community associations. More importantly FLAG vetted new members via portfolio review—jurors only admitting applicants with national or statewide recognition. For a short time FLAG and the Federation existed side by side with many artists holding joint membership. In 1959 the Florida Federation of Art opened its first real headquarters in the small town of DeBary. The opening reception was reported to have drawn over a thousand guests who apparently blocked all local streets with their cars and continuously drained the center's four punch bowls.[84] Despite the initial send up, the federation was in decline. Statewide focus had shifted from the older consortium that included a large number of amateurs to the new organization that promoted professional artists.

Since its incorporation FLAG has organized annual member exhibitions as well as symposia and panel discussions of interest to the state's professional artists.[85] The 1954 symposium carried the provocative title, "Three and a half million amateur painters in America! What effect will this growing development have on professional art?"[86] In 1958 the topic was "Why Art in Public Buildings and the Need for a State Art Commission."[87] The 1955 symposium perhaps drew the most comment with its title, "Should Artists Eat?" The panel of notables decided that artists could survive if they "adjust production to a quality and character possessing salability." One participant countered that "any art career was 'self-indulgence' and the artist should take the consequences."[88]

Professionalizing the arts was taking place in cities throughout Florida including Jacksonville which continued be one of the state's most populous areas. During World War II the city's seaport, flat terrain, and year-round good weather made it a natural location for naval and air bases. Hundreds of thousands of service people poured into town for training; a significant number came back after the war.[89] The city's cultural organizations quickly expanded to keep pace. The local art association found itself in a whirlwind of change. In 1943 the Fine Arts Society of Jacksonville changed its name to the Arts Exhibition Club only to change it again in 1947 to the Jacksonville Arts Club. The following year club members purchased the Fleming Mansion in the Riverside neighborhood for their first permanent home. Along with the change of address came a more radical shift: the art club incorporated as the Jacksonville Art Museum. The organization had come a long way from its roots as a volunteer organization supporting local artists. While Jacksonville artists continued to serve on its board, managing the museum passed to a professional staff. In 1966 the museum moved into a building on the city's south side specifically designed to house a permanent collection as well as space for large-scale exhibitions and educational programs for children and adults.

Jacksonville became home to two art museums when the Cummer Gallery of Art opened on November 10, 1961. The new museum's collection of Old Master and American art was assembled over fifty years by Nina Cummer. When the founding director died shortly before the museum opened, Joseph Jeffers Dodge (1917-1997), longtime curator of the Hyde Collection in Glens Falls, NY, took over the position. Jerry Dodge, as he was known to all, worked tirelessly to broaden the appeal of visual arts in his new town. He not only assembled important exhibitions to draw visitors to the Cummer, but also lectured throughout the city hoping to pique curiosity about the museum. As a professional painter himself, Dodge was an enthusiastic promoter of local artists. In 1972 he retired from the museum to paint full time. A year later, he was instrumental in the creation of Art Celebration!, a group that included many of the city's major professional artists.

For almost two decades the group's popular exhibitions were "must see" events.[90] Oftentimes Dodge would find inspiration for his work in local landscapes, particularly those found outside his studio windows on Silversmith Creek or at Fort Clinch on nearby Amelia Island. In *Sunday Afternoon at Fort Clinch* (Fig. 13), Dodge crowds the remnants of the nineteenth-century garrison into the lower half of the canvas. Overhead, bands of clouds block all possibility of the sun's breaking through.[91] Dodge mused nostalgically about this locale, "It's my favorite spot in Florida—a bit less so now that it's being restored. It was better, I think, a couple of years ago when it was more of a ruin, when it seemed like one was discovering it for oneself for the first time."[92]

Jacksonville at mid century had a strong local art association, a growing number of professional artists, and the makings of two art museums. Despite these advancements, the city still lacked a college that conferred a degree in art. Jacksonville's Edward Waters College, founded in 1866 to educate freed slaves, remained the city's only institution of higher education until 1934 when Porter University opened as a night school. Renamed Jacksonville Junior College in 1935, it formed the foundation of what would become Jacksonville University in 1957. The university always had a strong music program, but it was not until 1961, at the urging of Frances B. Kinne, that the College of Music gave way to the College of Music and Fine Arts.[93] One of the new department's energizing forces was Memphis Wood who had been teaching art in city since her arrival in 1929.[94]

The University of North Florida, founded in 1972 as part of the University of Florida system, always had an art department. Courses in commercial design, photography, drawing, and printmaking were taught by art professors such as Wellington C. Morton, Carlton R. Williams, and Charles F. Charles.[95] Over the next quarter century the number of art professors teaching at the University of North Florida, Jacksonville University, and later at Florida Community College-Jacksonville continued to grow, especially as departments expanded to include new disciplines such as electronic media. These faculty members would join the increasing number of professional artists calling Jacksonville home.

While Jacksonville was growing to over a million residents, St. Augustine remained very much a town—more specifically, an art town. Throughout the 1940s the St. Augustine Arts Club dominated local artistic affairs. As it had since its inception, the club continued its partnership with local businesses to foster

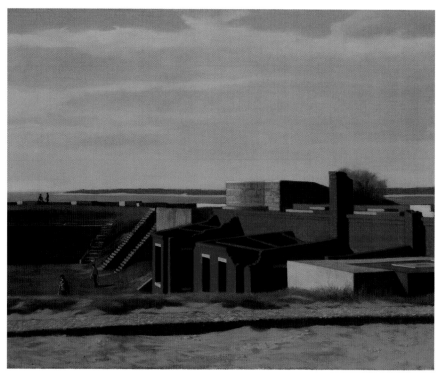

Fig. 13 Joseph Jeffers Dodge *Sunday Afternoon at Fort Clinch,* 1964
Oil on canvas Collection of Gretchen and Steve Lotz

an art colony capable of luring artists to town for the winter. The one amenity still lacking was an official home for meetings, exhibitions, and events. Post-war optimism convinced club members that the time was right to pursue this long-time dream. In December 1945 the club purchased land; soon thereafter, fundraising for a building began in earnest. Understanding the benefit to the local economy of an expanded art community, St. Augustine politicians and business owners joined the effort.[96]

At the same time, St. Augustine was grappling with conflicts about "modern" art similar to those that arose earlier in Winter Park and Maitland. In the summer of 1946 an Arts Advisory Committee made up of proponents of modernism attempted to promote new styles by expanding the content of club exhibitions. The Lindenmuths and the L'Engles, fixtures of the local art scene, spearheaded the group. The committee's success was cut short when a conservative faction won election to leadership positions. Fairly quickly, the new officers yielded to

local business interests that wanted to focus on drawing more traditional artists to town.[97] "Modern" art would have to wait.

Among the more well-known traditional artists lured to St. Augustine for the winter were Anthony Thieme (1888-1954) and Louis Kronberg (1872-1965) who arrived in 1947 and 1948 respectively.[98] But not all artists coming to St. Augustine fit neatly into the traditionalist camp. In fact, the art of Earl Cunningham (1893-1977), who became a permanent resident in 1949, defies all attempts at categorization. Self-described as a "primitive artist," Cunningham has been called everything from Grandpa Moses to an American Fauvist.[99] His painted landscapes are visions of past and present commingling in a vividly-colored world devoid of optical perspective. In *Sanctuary* (Fig. 12) the Florida marshland teems with flamingos, cranes, wood ducks, and other more generic bird forms enjoying the lush landscape with nary a predator in sight. But Man hovers on the horizon, his schooner resembling shark's teeth and his looming destruction foretold by the felled trees.

Despite many creative fundraisers, St. Augustine's building campaign languished. In 1947 club officers expanded their appeal to local residents. The new building, they pointed out, was not only for artists, but also for the enjoyment and cultural enrichment of the entire community. To cement its community outreach, in April 1948 the club changed its name to the St. Augustine Art Association announcing that membership was open to anyone "who wishes to enjoy and participate in the activities of the association."[100] Thereafter membership, which totaled 198 in 1948, soared to 532 in 1949, and to an astonishing 800 in 1950.[101] The decision to embrace the entire community, while laudable, had far reaching ramifications. In a very short time amateurs and non-artists significantly outnumbered professional members. Not unexpectedly resentment arose from the professionals who worried about the diminution in quality of association exhibitions.[102]

Fundraising for the building continued into the early 1950s. Finally in September 1953 construction began. Less than five months later on January 30, 1954 the Art Center of the St. Augustine Art Association opened its doors. The center quickly fulfilled its role as the community's base for art and culture. Amid all of the celebration, however, many professional artists who had supported the association for decades were growing disenchanted. Perhaps too much control has been vested in local business interests, or too much power

had been granted to club officers with hidden agendas. Whatever the reason, professional artists began to withdraw from the organization. More importantly, when the campaign to lure northern artists to the city faltered, St. Augustine's dream of becoming a winter artists' haven equal to summer art colonies such as Rockport and Provincetown faded from sight.[103]

In 1969 when local art activist and award-winning artist Jean Wagner Troemel moved to town, there were very few venues for professional artists to show their work. Troemel recalled that by 1982, the number of art galleries had dropped to three.[104] Rather than bemoan the lack of exhibition space, Troemel founded Professional Artists of St. Augustine Fine Arts Gallery, always shortened to its culinary acronym P.A.St.A. After a quarter century of presenting St. Augustine artists, the non-profit organization now refers to itself as "The oldest gallery in the oldest city in the USA." Asked why she thought St. Augustine's popularity as a home for artists diminished somewhat in the 1960s, Troemel immediately replies, "It was abstraction. An artist does not need to sit in front of a beautiful Florida landscape to create a non-objective painting." And why did the city rebound as an art community? "It's still affordable, and it's still beautiful." Today over forty galleries line St. Augustine streets, testifying to the city's viability as a home for the arts.

St. Augustine is not only home to professional and amateur artists, but to art students as well. In what seems a particularly fitting evolution, Henry Flagler's Hotel Ponce de Leon was reborn as Flagler College in 1968. The magnificent edifice that was instrumental in launching St. Augustine as a winter home for artists was suddenly teeming with students. From the college's beginning, classes in fine arts were held in the same art studios once occupied by such heralded artists as Martin Johnson Heade.[105]

Post-war optimism spilled over to towns farther down the coast. Like their St. Augustine colleagues, the Daytona Art League flourished throughout the 1920s and 1930s despite being housed in private homes, studios, and the YMCA. By the mid-1940s the league needed its own space. In 1945 a suitable lot became available to the league at a price described as "exactly the amount they had in their treasury." Thereafter "all manner of money-making activities" produced the necessary funds for a building. On April 4, 1948 the Daytona Beach Art Center held its grand opening. It took a great many volunteers to run the league and the expanded activities of the new center. Eventually two separate

operating units evolved; not surprisingly conflicts arose when agendas over-lapped. In 1961 harmony was restored when both groups consolidated into the Art League of Daytona Beach, Inc.[106]

The Art League's leadership eventually passed from Don J. Emery to his son Don Woodruff Emery. An exhibition of their work in 1953 at the Research Studio in Maitland was described in a local newspaper as being of "unusual interest since it blends the conservative, yet vigorous work of the older Mr. Emery with the more abstract paintings of his son"[107] The article adds that the Emerys' form of modernism is a "pleasant reaction to so much in recent painting that has been chiefly accidental confusionism." This local reviewer probably would have enjoyed the artistic style of another Daytona artist and league favorite, James Calvert Smith (1879-1962). Although he was born in Micanopy near Gainesville and worked for the *Florida Times-Union* in Jacksonville, Smith made his career as an illustrator in New York and Connecticut. In 1947 he returned to the state to settle in Holly Hill near Daytona.[108] In 1952 Smith endeared himself to the city by creating a series of watercolors depicting the "history" of Daytona Beach. Rather than specific events, these candy-colored images are nostalgic turn-of-the-century vignettes set in locales easily recognizable to longtime residents (Fig. 14).

Fig. 14 James Calvert Smith *So This is Main Street*, c.1950
Graphite and watercolor on paper
Gift of Mrs. Jeanne Goddard Acq. No. 90.08.008
Museum of Arts and Sciences, Daytona Beach, Florida

In 1957 the city celebrated the opening of the Daytona Beach Community College (now Daytona Beach College). Although the college offered various art courses, the photography department quickly became a standout. Richard Turner, an influential faculty member who taught and practiced commercial photography, was a major force behind the department's rise to prominence. In 1992 the college cemented its commitment to photography when it opened the Southeast Museum of Photography. Now a much-heralded institution, credit for its creation belongs in large part to then-president Philip Day who recognized the benefits of narrowly focusing the museum's mission. Specializing in photography was the obvious choice: the college had a superior department, material for a permanent collection was available, and photographic images could serve a wide range of college disciplines. The local community benefited by association. Daytona Beach suddenly had the distinction of housing the only museum in the southeast dedicated exclusively to photography.

In Daytona Beach the local art association began at a picnic; in New Smyrna Beach it began at lunch. In November 1957 fifteen local artists "sat down to lunch at Ferrucci's Restaurant." Before dessert was served, the Artists' Workshop had been born.[109] Thereafter events moved quickly. Its charter approved by March 1958, the group held its first exhibition two months later at the Bank of New Smyrna and Dwight's Office Supplies. Three hundred people turned out for the opening. By year's end, membership totaled fifty-one. A newspaper photograph from 1958 shows workshop members displaying prize-winning paintings—all abstractions.[110] Apparently, the commotion about "modernism" that had roiled local art associations earlier in the decade had passed. In 1980 the Artists' Workshop acquired permanent space for classes, meetings, and exhibitions in downtown New Smyrna, a location it still maintains.

In 1961 Doris Leeper (1929-2000) won first prize at the Artists' Workshop's "Fourth Annual Exhibit."[111] Little did fellow members know that this relative newcomer would launch New Smyrna Beach into the national spotlight. Leeper first came to the area in 1949 during spring break from Duke University. Eighteen years later she returned to nearby Eldora to buy what she deemed a

piece of paradise: a house with endless frontage on Mosquito Lagoon and not a neighbor in sight. In 1960 Leeper became a full-time resident and full-time painter and sculptor; within two decades her art was nationally recognized.[112] In the 1970s she also focused her considerable energy on preserving the pristine landscape she held dear.[113] At the same time Leeper began work on what would become her most lasting legacy, the creation of the Atlantic Center for the Arts. With equal devotion to art and the environment, Leeper's vision was to create a tranquil retreat in a natural environment where renowned artists from all disciplines could gather. It took five years, but in 1982 "with the fervor of a Pentecostal preacher and the calculating coolness of a politician hunting for crucial votes," Leeper opened the center on sixty-nine acres of tidal estuary near Trumbull Bay.[114] Its first residency included sculptor Duane Hanson, poet James Dickey, and composer David del Tredici. Now considered one of the world's premier artists' retreats, as well as a model for the integration of man-made and natural environments, the center has earned for New Smyrna Beach a designation as one of America's "best small art towns."[115]

The bucolic paradise of the Atlantic Center for the Arts presents a striking contrast to the technology-charged ambiance of Cape Canaveral a scant twenty miles to the south. Surprisingly, the space program that began in 1955 did little to alter the small-town feeling of its neighboring coastal communities. An hour away in Orlando, however, the entire aviation industry was having a major impact. Known during the war as the "Air Capital of Florida," Orlando's two airports and several aircraft manufacturers brought thousands of people to town.[116] By 1950 the local population had swelled to over 50,000. Support industries for aviation grew again when missal maker Glenn L. Martin Company (later Martin Marietta, now Lockheed Martin) moved into south Orlando. And this was all before Disney. Orlando's economy boomed along with its population. It was time for the arts to reflect Orlando's new status as a major Florida city.

Progress began in 1953 when local leaders set aside prime property between Lakes Estelle and Formosa "for cultural purposes." It was named Loch Haven Park. The usual political maneuvering made progress difficult. Rather than wait for the dust to settle, the Orlando Art Association decided to make use of the donated estate of Hattie and Florence Hudson on Washington Street. On October 4, 1957 the Hattie Hudson Memorial Art Center opened as the association's first real home in its thirty-three year existence.[117] Even from the outset, it

was clear that this arrangement was temporary. The same year a campaign began for a building in Loch Haven Park designed by architect James Gamble Rogers, II. After starts and stops, in December 1960 the association moved into its newly built facility named the Loch Haven Art Center. The dream expressed as early as 1927 that the, "Association is looking forward confidently and eagerly to establishing an Art Institute in Orlando with an adequate club house, a school of art, and a permanent art gallery," finally came true.[118]

Four years later in 1964 David Reese (b. 1915) left the directorship of the Telfair Academy of Arts and Sciences in Savannah to take a similar position at the Loch Haven Art Center.[119] A native of Georgia and former member of the Art Students League, Reese was familiar with the area; he was stationed in Orlando during the war where he designed visual aids for the U.S. Air Corps. As director Reese marshaled local resources to transform the institution from an art center into an art museum with programs for the entire community. After opening a major building expansion in 1969, Reese announced that it was time for the center "to think about a permanent collection." In June 1986 the center changed its name to the Orlando Museum of Art at Loch Haven to reflect its broadened mission. On January 9, 1992 the museum opened an expanded and renovated facility bearing the name Orlando Museum of Art.

Reese directed the institution until his retirement in 1976. Despite his demanding job, he always found time for his own art. A prolific artist, Reese was known for his colorful watercolors filled with bravura brushwork and bright colors. He described his own work as "intense looks at nature."[120] Among his favorite subjects were the lush floral specimens native to Florida. In *Seagrapes* Reese constructs a vibrant composition by filling the paper edge to edge with intertwined red and green leaves set off against a tangled mass of dark vines (Fig. 15).

The evolution of the Orlando Art Association was only part of the city's cultural advancement. The arts community got a further boost when two major educational institutions opened in consecutive years. From the beginning both included art programs. Valencia Community College formally began in 1967 with a charter art faculty of one: Que Throm. The college soon began offering a range of art foundation courses and staff was added. The big advancement occurred in 1981 when the art department moved to the new East Campus to a building specifically designed for art, music, and theatre.

Fig. 15 David Reese *Seagrapes* Watercolor on paper
Sam and Robbie Vickers Florida Collection

In 1968, hoping to take advantage of the space program—then only one year from landing a man on the moon—the Florida Technological University opened in Orlando. Steve Lotz was the sole art faculty, having been lured from Jacksonville University. To the surprise of the administration, enrolling along with the expected technophiles was a significant number of would-be artists. Lotz's classes were so large that by year two he was able to hire Johann Eyfells. The next year's hires were Walter Gaudnek, Hans Krenn, and Gary Downing, followed a year later by Charles Wellman. It was a powerhouse department. Responding to the widespread student interest in arts and humanities, FTU's founding president Charles Millican began to broaden the school's curriculum. To reflect its expanded mission, the university was renamed the University of Central Florida.

Close by in Winter Park Jeannette and Hugh McKean kept up their almost zealous promotion of the arts. The combination of Hugh's college positions and

Jeannette's considerable inheritance allowed the couple to give their imaginations full rein. Still legendary was their "Drive-By" exhibition of Tiffany windows installed so that they could be seen from the car.[121] Other endeavors were more conventional and more lasting. The Morse Gallery of Art continued to exhibit local, national, and international art. In 1953, for example, McKean used his considerable influence to bring in an exhibition of contemporary arts and crafts from India. Its only other U.S. venue was the Smithsonian.[122]

The same year, Contemporary Arts, a New York non-profit organization, gave Jeannette a solo show at its East 57th Street gallery.[123] Always promoters, the McKeans used that occasion to successfully land a simultaneous New York exhibit for Rollins students and faculty at the Argent Gallery.[124] Closer to home, in 1956 they opened the Center Street Gallery in Winter Park.[125] For a short time the gallery was adjacent to the original gallery of the same name founded in 1951 by Hungarian artist Tibor Pataky. His exhibitions of local art included abstractions and "enough realistic scenes so that no one unacquainted with the modern idiom need feel lost." Pataky's only request was that visitors "park their prejudices outside long enough to let each picture speak to them, if it can."[126] The McKean's version of the gallery was grander and offered a mix of antiques, curios, and contemporary art.[127] Quickly outgrowing the space, they moved their gallery to a prominent Park Avenue location where for decades it remained a fixture for art enthusiasts.

The gallery's immediate neighbor on Park Avenue was the Golden Cricket, a shop where Harold McIntosh (b. 1927) exhibited paintings for years. When the McKeans bought the shop and expanded to two storefronts, McIntosh moved over to the Center Street Gallery.[128] Born in Detroit, McIntosh's ties to Winter Park go back to the 1940s when his family began visiting the area. As a very young artist, he was "discovered" by Research Studio director André Smith as he painted outdoors in Eatonville. McIntosh remembers Smith swerving his big car to the side of the road to take a look. Impressed with what he saw, Smith invited McIntosh to tea. A number of resident fellowships at the Research Studio followed. McIntosh's painting *Spring Greens* shows off the natural artistic skills recognized early by Smith and others. The vibrant composition deftly captures the sparkle of sunlight on waving pine boughs (Fig. 16). The artist's talents extended to teaching. For years McIntosh was a popular art instructor throughout central Florida including a long association with what is now the Orlando Museum of Art.

Fig. 16 Harold McIntosh *Spring Greens* Oil on canvas
Collection of the artist

The McKeans expansions into the art world did not stop with the Center Street Gallery. On February 21, 1955 the Morse Gallery of Art opened an exhibition featuring the work of Louis Comfort Tiffany. It was the first critical exhibition in decades of the once acclaimed artist's work. Its enthusiastic reception energized the McKeans to assemble what ultimately would become the largest and most comprehensive collection of Tiffany objects in the world. In 1977 the gallery changed its name to the Charles Hosmer Morse Museum of American Art and moved off campus to Welbourne Avenue. On July 4, 1995 Winter Park celebrated the opening of the museum's new building on Park Avenue. Sadly, neither McKean lived to see the event.

Winter Park art enthusiasts also benefited from other major benefactors including George and Harriet Cornell whose contribution in 1976 underwrote construction of a fine arts complex on the Rollins College campus. Included were funds to enlarge and renovate what had been the Morse Gallery. Renamed the Cornell Fine Arts Museum, the college once again had a significant home for

the arts that presented not only its permanent collection, but also wide ranging exhibitions including shows by students, faculty, and prominent local artists.

The mid 1970s saw the beginning of another significant home for Winter Park artists. In 1975 William S. Jenkins—by day owner of a successful construction company, by night talented artist—created the Crealdé School of Art. Jenkins' mission was straightforward: to provide local artists with affordable studio space and to foster budding artists by offering equally affordable classes in a wide range of media. The school found an immediate niche. Today over forty professional artists teach and work at the facility.[129]

Maitland's fate as an art community ebbed and flowed after the war. In the 1930s the young city was catapulted to prominence when André Smith opened the Research Studio. The program was extraordinary in every sense of the word from its avant-garde mission to its fantastic Mayan-Deco architecture. But it was clearly a one-man show. Until his death in 1959 Smith maintained complete control over all activities including selecting artists for winter residencies. In 1955 Eugene Savage (1883-1978) accepted Smith's invitation for a residency. While there Savage exhibited a suite of twenty-two paintings and drawings entitled "The Everglades" (Fig.17). Savage saw Florida's "river of grass" as a kind of forest primeval teeming with mystery and beauty. A contemporary reviewer described the artist's works as, "rife with symbolism . . . in the drifting mist, the swaths of Spanish moss, the interpolation of animal life peculiar to the district, and the still reflections of gaunt cypresses in marshy waters."[130]

Despite its achievements, the Research Studio did not survive Smith's death. For ten long years the property sat idle, its glory days seemingly forgotten. In 1969 the city purchased the property with thoughts of building a cultural center. Nothing immediately materialized and the buildings fell further into disrepair. Concerned about preserving their architectural masterpiece, local citizens breathed life into the project in 1971 when, in short order, they formed the Maitland Art Association, leased the property from the city, and reopened the complex as the Maitland Art Center.[131] In 1982 the center was listed on the National Register of Historic Places. Smith's focus on American art by local, regional, and national artists is still maintained as part of the center's wide ranging educational activities. Today the Maitland Art Center finds itself at the hub of the local arts community now called the "Cultural Corridor."

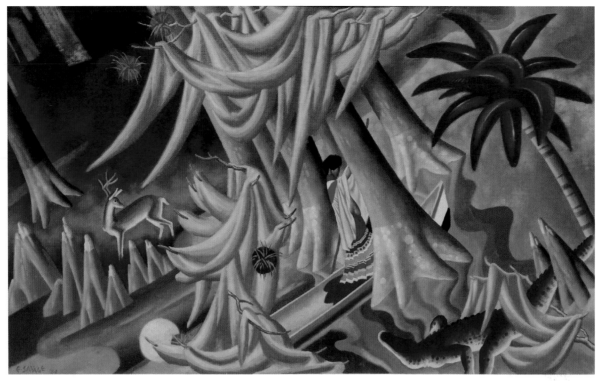

Fig. 17 Eugene Savage *Near Trafford, Everglades*, 1954 Oil on canvas on board
Museum Purchase, AP.2007.2.17 Cummer Museum of Art & Gardens, Jacksonville, Florida

The college town of DeLand continued to foster its share of artists over the second half of the twentieth century. Among the most colorful, talented, and enthusiastic were the artist couple Harry Louis Freund (1905-1999) and Elsie Bates Freund (1912-2001).[132] In the late 1930s Louis was a WPA muralist in Arkansas. In 1940 he and Elsie, a nationally-known jewelry designer, founded an art school in Eureka Springs, Arkansas in a house once owned by Carry Nation appropriately named "Hatchet Hall." They were lured to central Florida in 1949 by a "particularly harsh winter," that propelled Louis to accept a position as art instructor at Stetson University. For years thereafter Elsie told of their inauspicious entry into DeLand "dangling on the end of a tow truck" because their car had broken down outside town.[133]

The Freunds would escape many more brutal Arkansas winters in DeLand. From 1951 to 1959 Louis chaired Stetson's art department and from 1959 until his retirement in 1967 he was the university's artist-in-residence. Their talents did not go unnoticed. Louis was commissioned to paint murals for state post offices and hospitals while Elsie sold her innovative jewelry throughout the state, particularly at Jane Hershey's gallery in Sarasota. Grateful for the patronage, they gave back in equal measure. Among his many services to the state, Louis worked as longtime chairman of the exhibition committee for the Florida Artist Group, and served as president in 1958 and 1959. Their most lasting contribution, however, came in 1952 when they founded Florida Craftsmen. Begun primarily to provide more exhibitions, the Freunds' fledgling organization has grown over the past six decades into a major advocate for Florida's craft artists.

Louis Freund's painting *Florida Swamp* (Fig. 18) shows the artist's ready admixture of Midwestern Regionalism, reminiscent of his home state hero Thomas Hart Benton, and his own developed style of loose, rich brushwork. The jagged, dead limbs of the cypress trees are a dramatic foil to the lush vegetation that fills the rest of the canvas.

As the Freunds were being towed into DeLand, a group of determined local women were mobilizing to create a museum. The result was the DeLand Children's Museum that opened in 1951. From its beginning the museum offered classes in art, science, and history. A move to a larger home allowed for the addition of adult classes. In 1965 the organization incorporated as the DeLand Museum. Despite its broad mission, the visual arts were always the museum's primary focus. In 1985 the institution solidified that focus by reorganizing into the DeLand Museum of Art. A final move to new facilities that included exhibition galleries and the necessary support spaces occurred in 1991.[134] Of particular interest is a recent trustee decision to limit the museum's exhibitions and programs to Florida-related art. To reflect the new mission, the institution's name was changed to the Museum of Florida Art. At last, one hundred and twenty years after Miss Tuttle taught the first art class at Stetson, Florida art has a place to call home.

· · · · · ·

One of Florida's license plates reads, "State of the Arts." While true, it was a long time coming. More importantly, maintaining this "state" is no easy matter. Creating, exhibiting, and understanding twenty-first century art demands more of everything: space, technology, materials, exposure, education. From Jacksonville to Orlando to New Smyrna Beach, communities have responded by creating new facilities and expanding existing ones to better accommodate both the art and the growing number of art-loving public who wants to see it. In the last few years alone, completely new facilities have been built for the Museum of Contemporary Art Jacksonville and the Southeast Museum of Photography. Major renovations and expansions took place at the St. Augustine Art Association, the Cummer Museum of Art & Gardens, Museum of Arts and Sciences in Daytona, and the Cornell Fine Arts Museum. At the same time, a totally new museum opened in Loch Haven Park in Orlando: the Mennello Museum of American Art. Even the Atlantic Center for the Arts, tucked away in its bucolic setting, was willing to alter its near-perfect balance of buildings and nature to provide more space for public programs. The "State of the Arts," it appears, grows stronger every day.

In 1564 Jacques Le Moyne started it all when he painted the first version of the strange new world that lay before him. For centuries thereafter, artists have been equally intrigued by the area's artistic possibilities. What follows here are updated images of local people, places, and things, seen through the particular lens of artists now living and working in the place Ponce de León called *La Florida*.

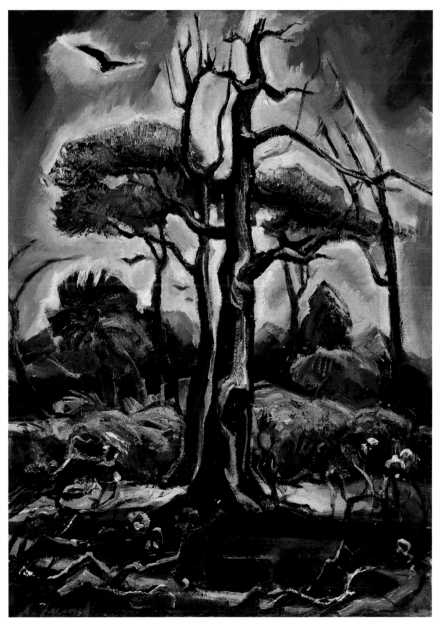

Fig. 18 Harry Louis Freund *Florida Swamp* Oil on board
Florida Collection of Hyatt and C.C. Brown

NOTES

1. Michael Gannon, *Florida: A Short History*, Gainesville, FL, 1993, pp. 4-5. This small, but choice, book was written for those who would like to know something about Florida's history, "but not that much!" Gannon, p. xi.

2. For more on Le Moyne see Paul Hulton, *The Work of Jacques Le Moyne de Morgues: A Huguenot Artist in France, Florida, and England*, 2 vols, London, 1977.

3. Thoughtful essays by Wendell Garrett and Nicolai Cikovsky, Jr. on the role and commitment of artists to preserve the state's vanishing landscapes are found in Gary R. Libby, *Coast to Coast: The Contemporary Landscape in Florida from the Geiger-Percy Collection*, ex. cat., Museum of Arts and Sciences, Daytona Beach, FL, 1999, pp. 15-18 and 19-20.

4. Gannon, p. 143.

5. New Smyrna Beach has the distinction of being listed by John Villani in *The 100 Best Small Art Towns in America*, Santa Fe, NM, 2nd ed., 1997, pp. 44-45.

6. Gannon, p. 40.

7. An extensive history of Florida art and artists can be found in Maybelle Mann, *Art in Florida 1564-1945*, Sarasota, FL, 1999. See chapters 1-2 for a survey of art before Florida's statehood.

8. Ibid., chapters 3-4.

9. D. Webster Dixon, "Notes of a Southern Journey," *The St. Albans Messenger*, Albans, Vermont, p. 12, cited from James Robertson Ward, *Old Hickory's Town: An Illustrated History of Jacksonville*, Jacksonville, FL, 1985, p. 158.

10. By the mid-1870s, Jacksonville boasted many impressive tourist hotels. See Ward, pp. 157-159. Dixon (see note 9) called the city, "the chief emporium of East Florida," cited from Ward, p. 158.

11. See Gary R. Libby, ed., *Celebrating Florida: Works of Art from the Vickers Collection*, Gainesville, FL, 2nd ed., 1996, pp. 48-49.

12. Moran was one of many magazine and book illustrators sent on assignment to Florida. See Mann, pp. 53-60.

13. For discussion of Moran's painting of Fort George Island see Libby, *Celebrating Florida*, p. 56. Excerpts from the article by Julia E. Dodge, "An Island of the Sea," *Scribner's Monthly*, vol. XIV, no.5 (Sept. 1877), pp. 652-661, are included in Nancy K. Anderson, *Thomas Moran*, ex. cat., National Gallery of Art, Washington, DC, 1997, p. 117.

14. See Libby, *Celebrating Florida*, pp. 130-131.

15. Mann, pp. 110-115.

16. See Tanja Jones, Hope McMath, Aaron de Groft, and Maarten van de Guchte, *The Cummer Museum of Art & Gardens* (collection handbook), Jacksonville, FL, 2000, p. 148.

17. The 40-mile trip from Jacksonville to St. Augustine was accomplished by taking a southbound steamboat on the St. Johns River and transferring to an eastbound narrow gauge railroad for the last fifteen miles. See Les Standiford, *Last Train to Paradise: Henry Flagler and the Spectacular Rise and Fall of the Railroad that Crossed an Ocean*, New York, 2002, p. 54. See also Roberta Smith Favis, *Martin Johnson Heade in Florida*, Gainesville, FL, 2003, p. 42.

18. Gannon, p. 63.

19. What would ultimately be named the Florida East Coast Railway on September 9, 1895 was a combination of existing, reworked, and new lines merged over the years by Flagler. See the exhaustive history by Seth H. Bramson, *Speedway to Sunshine: The Story of the Florida East Coast Railway*, 3rd ed., Erin, Ontario, 2003.

20. Favis, p. 43 ff.

21. Ibid., p. 41 ff.

22. Ibid., p. 48 and pp. 60-66.

23. Ibid., pp. 11-13.

24. Bramson, pp. 18-19 contains the "family tree" of every railway line ultimately incorporated into the Florida East Coast Railway system, together with vast amounts of information about acquisition dates, mileage, patents, and deeds. This author will leave it to railroad buffs and other like-minded people to figure out precisely when each train arrived at each town.

25. Bo Poertner, *Old Town by the Sea: A Pictorial History of New Smyrna Beach*, Virginia Beach, VA, 2002, p. 90. Flagler would use New Smyrna Beach as a staging ground for his railroad as it pushed on to Palm Beach and Miami.

26. Standiford, p. 59.

27. Poynter Institute online statistics at poynter.org/florida

28. Winter Park was indeed small; in 1887 one hundred and two voters approved the town's incorporation. See Robin Chapman, *The Absolutely Essential Guide to Winter Park*, Winter Park, FL, 2001, p. 13.

29. Olin Library Archives at Rollins College contain a complete list of art faculty from 1885 to the present. Special thanks to Gertrude F. Laframboise, archives specialist, for her assistance.

30. Olin Library archives. Guild was also one of nine women who founded the Winter Park Circulating Library.

31. See typed manuscript by W. S. Gordis, "John B. Stetson University: History and Reminiscences," n.d. (c. 1947). Warren S. Gordis began teaching Latin and Greek at Stetson in 1888 and served the university until the 1940s. His invaluable insider's account of Stetson's history, including names of faculty and evolution of academic departments, can be found online at the university's duPont-Ball Library website: www.stetson.edu/library/alumni_Gordis.

32. Ibid., ch. I, p. 40.

33. Ibid., ch. II, p. 19.

34. Gannon, p. 85 and p. 139. In the years since 1990, California and Florida have maintained their relative rank while Texas has overtaken New York for third place.

35. At this writing, the archives of the Fine Arts Society of Jacksonville are unavailable. Information cited here is drawn from recent press releases issued by the Museum of Contemporary Art Jacksonville.

36. See checklists of the Orlando Art Association exhibition 1927 and the 8th circuit exhibition Southern States Art League in the archives of the Orlando Museum of Art, scrapbook dated 1924-1933. Harrison studied at the Cooper Union Art School and the Art Students League, see Peter Hastings Falk, ed., *Who Was Who in American Art*, Madison, CT, 1985, p. 265. Washburn studied at Pratt Institute Art School and Broadmoor Academy, and was elected to the National Association of Women Painters and Sculptors, see Falk, p. 661.

37. A newspaper article written about 1927 describes Wolfe as "young but vigorous" and adds that he came from Chicago where he was chairman of the Art Institute. Writing about the First Annual Exhibition of the Florida Federation of Art in 1929, a reviewer notes, "The work of Mrs. Reeves is known to those who have attended Florida Federation and Southern States League exhibits of the last year or two. Both she and her co-director won prizes in the recent Jacksonville exhibit, in fact between them they walked away with most of the awards at that show." See archives Orlando Museum of Art, scrapbook 1924-1933.

38. Hilton exhibited twenty-one watercolors in 1930 at the Orlando Art Association, all of which were local scenes. Born in London, Hilton moved to Chicago before coming to Florida c. 1925. Active in local artistic affairs, Hilton served as secretary of the Fine Arts Society of Jacksonville, director of the Jacksonville Art Academy, and exhibition chairman for the Florida Federation of Art. See undated newspaper article, c. 1930, archives Orlando Museum of Art, scrapbook 1924-1933.

39. See undated newspaper articles in the archives of the Orlando Museum of Art, scrapbook dated 1924-1933.

40. In addition to those Jacksonville artists already mentioned, C. Barrett-Strait, Merrydelle Hoyt, Emma Craddock Just, Burdette Martin Phelps, and Walter W. Thompson took part. Many of the exhibited works carry titles relating them to Florida: *Cloudy Morning on the St. Johns*, *Docks at Jacksonville*, and *Florida Water Oak*, among others.

41. "Florida Artists and their Work: Report on 4th Annual Convention of the Florida Federation of Art," see archives Orlando Museum of Art, scrapbook 1924-1933. Extensive Federation archives are deposited in Special Collections at the Smathers Libraries, University of Florida, Gainesville. Missing from the archives are annual reports from 1931-1934.

42. Gannon, p. 73.

43. See "Civic Art Institute Progress Report," vol. I, no. 1, 1940, unpaginated foreword. Tremendous thanks for tracking down this elusive report goes to Raymond W. Neal, Senior Librarian Florida Collection, Jacksonville Public Library.

44. Cummer collection handbook, p. 186.

45. In 1934 Frieseke dictated his Florida memories to his daughter Frances. Intended for his family, it is a charming tale of the family's move to Jacksonville in 1881 after his mother's death. The manuscript with the artist's marginal sketches was published by his grandchildren in conjunction with an exhibition of his Florida scenes. See Frederick C. Frieseke, *Uneventful Reminiscences: A Childhood in Florida*, ex. cat., Hollis Taggart Galleries, New York, 2000.

46. Robert W. Torchia, *Lost Colony: The Artists of St. Augustine, 1930-1950*, ex. cat., The Lightner Museum, St. Augustine, FL, 2001, p. 9.

47. "New Art Club President is Appreciative," *St. Augustine Record*, Dec. 22, 1931, cited from Torchia, p. 13.

48. Ibid., p. 20.

49. Ibid., pp. 81-84. See also Gary R. Libby, *Coast to Coast*, p. 82.

50. Ibid., pp. 74-75.

51. History described here found in "A Short Story of the Art League of Daytona Beach: As Seen through Newspaper Articles, Minutes, and Interviews," pamphlet, 1982, n.p. Special thanks to Connie Krzyzowski for her assistance with the archives.

52. Archives, Art League of Daytona Beach.

53. Special thanks to Gary R. Libby for access to his manuscript for a dictionary of Florida artists to be published shortly.

54. Published pamphlet, Art League of Daytona Beach, n.p.

55. The property is located at 317 Ocean Shore Boulevard. See Kevin M. McCarthy, ed., *The Book Lover's Guide to Florida*, Sarasota, 1992, p. 86.

56. Ibid. When "The Battleship" was acquired by Embry-Riddle Aeronautical University for its president's residence in 1971, Dana's sculptures were donated to the Fred Dana Marsh Museum at Tomoka State Park. See also Anne E. F. Jeffrey and Aletta Dreller, *Art Lover's Guide to Florida*, Sarasota, FL, 1998, p. 31.

57. McCarthy, p. 86.

58. All of the information on the Orlando Art Association comes from scrapbooks in the archives of the Orlando Museum of Art. The newspaper articles have been trimmed so that no dates, pages, or names of newspapers remain.

59. See obituary for Davenport in *Orlando Sentinel*, Nov. 3, 1957. See also Falk, p. 150.

60. Archives, Orlando Museum of Art, scrapbook 1924-1933.

61. Ibid. See also Falk, p. 216.

62. Born in New York City, Ortmayer was a member of the National Sculpture Society and National Association of Women Painters and Sculptors. She was awarded the Anna Hyatt Huntington sculpture prize in 1935, see Falk, p. 462.

63. Archives, Olin Library, Rollins College.

64. The Treasury Section of Painting and Sculpture (called the "Section") was a New Deal program (not to be confused with the Federal Art Project of the Works Progress Administration) that created art to decorate post offices and courthouses built under the Public Buildings Administration. See Barbara Melosh, *Manhood and Womanhood in New Deal Public Art and Theater*, Washington, D. C., 1991, p. 4.

65. Archives, Olin Library, Rollins College.

66. Archives, Orlando Museum of Art, 1924-1933 scrapbook.

67. Archives, Olin Library, Rollins College.

68. *Winter Park Topics: A Weekly Review of Social and Cultural Activities during the Winter Resort Season*, Jan. 22, 1938.

69. Ibid., Mar. 16, 1942.

70. Goris, ch. IV, p. 61.

71. Ibid., ch. III, p. 36.

72. Archives, Orlando Museum of Art, scrapbook 1924-1933. See also Falk, p. 222.

73. *Winter Park Topics*, Jan. 11, 1935, p. 4.

74. Ibid., Mar. 9, 1935, p. 7.

75. Ibid., Mar. 16, 23, and 30, 1935.

76. Ibid., Mar. 16, 1935, p. 7.

77. Ibid., Apr. 20, 1935, p. 1.

78. Smith met Bok while designing sets for actress Annie Russell at Rollins College. Bok underwrote the construction of the Annie Russell Theatre on the Rollins campus. See undated pamphlet, Maitland Art Center.

79. Smith quoted from *Winter Park Topics*, Jan. 9, 1938, p. 7.

80. Ibid.

81. Charles Hyde Pratt, "Florida Byways," review in *Winter Park Topics*, Mar. 23, 1940, p. 3.

82. For the entire poem see *Winter Park Topics*, Mar. 16, 1940, p. 1.

83. Conspicuously absent from this discussion are the many galleries and dealers who have played pivotal roles in promoting Florida artists throughout the state and the country. Without these stalwart supporters, the history of Florida art would read much differently. Telling this story, however, must await a different forum.

84. Archives, Orlando Museum of Art, scrapbook, article from *Winter Park Sun Herald*, July 16, 1959.

85. At this writing FLAG had just completed its 57th annual exhibition at the Museum of Arts and Sciences in Daytona Beach.

86. Brochure, 1954-1955 Fifth Annual Exhibition Florida Artist Group.

87. Brochure, 1958-1959 Ninth Annual Exhibition Florida Artist Group.

88. Brochure, 1955-1956 Sixth Annual Exhibition Florida Artist Group.

89. Gannon, pp. 103-105.

90. Debra Murphy-Livingston, *Joseph Jeffers Dodge*, Jacksonville, FL, 2002, pp. 25-26.

91. For a discussion of Dodge's Fort Clinch paintings see Murphy-Livingston, pp. 52-53.

92. Ibid.

93. George Hallam, *Our Place in the Sun: A History of Jacksonville University*, Jacksonville, FL, 1988, p. 80.

94. Interview with Steve Lotz who was among the university's early art faculty, Jan. 4, 2007.

95. Information and statistics gathered from art faculty pages of UNF catalogues beginning 1972. Special thanks to Eileen D. Brady, Head, Special Collections and University Archives.

96. Torchia, pp. 27-28.

97. Ibid., pp. 28-30.

98. Ibid., p. 31.

99. Wendell Garrett, Virginia M. Mecklenburg, and Carolyn Weekley, *Earl Cunningham's America*, ex. cat., Smithsonian American Art Museum, Washington, DC, 2007, pp. 25, 84 and 92.

100. *St. Augustine Record*, Apr. 8, 1948 cited from Torchia, p. 32.

101. Torchia, pp. 32, 38, and 41.

102. Ibid., p. 43.

103. Ibid., pp. 48-49.

104. Interview with artist, June 7, 2007.

105. Special thanks to Christine Wysocki, archivist, Flagler College.

106. See "A Short Story of the Art League of Daytona Beach: As Seen through Newspaper Articles, Minutes, and Interviews," pamphlet, c. 1982, n.p.

107. See "New Exhibition on View at the Research Studio," *Winter Park Topics*, Jan. 30, 1953, p. 3.

108. Gary R. Libby, "James Calvert Smith," Museum of Arts and Sciences magazine, spring issue, 1986, p.14. See also Libby's dictionary of Florida artists to be published in 2008.

109. Undated newspaper article, c. 1977, archives Artists' Workshop. Special thanks to Nancy Hagood, Artists' Workshop member *extraordinaire*.

110. Undated newspaper article, c. 1958, archives Artists' Workshop.

111. For a complete chronology of Doris Leeper see Robert S. Lemon, Jr., *Doris Leeper: A Retrospective with a Chronology Compiled by James J. Murphy*, ex. cat. Cornell Fine Arts Museum, Rollins College, Winter Park, FL, 1995, pp. 82-92.

112. For an excellent account of Leeper's art see Lemon, pp. 1-29.

113. Lemon, p. 87 and Bo Poertner, *Old Town by the Sea: a Pictorial History of New Smyrna Beach*, Virginia Beach, VA, 2002, pp. 83-84.

114. Ibid., p. 137. See also website, Atlantic Center for the Arts.

115. John Villani, *The 100 Best Small Art Towns in America*, Santa Fe, NM, 2nd ed., 1997, pp. 44-45.

116. Wynette Edwards, *Orlando & Orange County*, Charleston, SC, 2006, pp. 106-113.

117. *Orlando Evening Star*, Sept. 27, 1957.

118. William, F. Blackman, *History of Orange County*, Orlando, 1927, p. 135.

119. *Orlando Sentinel*, Apr. 1, 1964.

120. Interview with artist in *Sentinel Star*, Feb. 1, 1976.

121. Morse Museum of American Art website.

122. *Winter Park Topics*, Mar. 6, 1953, p. 4.

123. Ibid., Mar. 6, 1953, p. 1.

124. Ibid., Mar. 20, 1953, p. 9.

125. Ibid., Jan. 6, 1956, p. 5.

126. Ibid., Mar. 9, 1951, p. 9.

127. *Winter Park Topics*, Jan. 6, 1956, p. 5.

128. Interview with artist Jan. 12, 2008.

129. Crealdé website.

130. *Winter Park Topics*, Feb. 11, 1955, p. 5.

131. Maitland Art Center brochure.

132. For detailed biographies of both artists see Alan DuBois, in the online Encyclopedia of Arkansas History and Culture.

133. For this and other insights about Elsie see, "In Remembrance" a memorial tribute by David Fithian in Florida Craftsmen Online.

134. See DeLand Museum of Florida Art website.

THE ARTISTS

LA FLORIDA

HOPE BARTON

Soft-spoken and thoughtful, Hope Barton's personal style is reflected in her intimate, atmospheric views of the Florida landscape. Quiet and contemplative, sensory and sensual, Barton's lush etchings and paintings are the tangible result of her long-standing love affair with the deep woods and marshes that inspire her.

Born in Colorado and raised in Oklahoma, Barton moved to Coral Gables with her family in late childhood. "Oklahoma was beautiful, but it was dry and there wasn't a lot of water," says Barton. "Florida was so different in comparison—waterskiing at Christmas and boating in the marshes— I grew to love it all."

Trained as a printmaker, Barton works from photographs to create her small jewel-like etchings. "I married a Florida native, a "cracker," and we lived on a lake for thirty-eight years. Our recreation as a family was boating and exploring, and I would take photos of the pines, palms and creatures we would see. I loved the small waterways—not the large rivers but the creeks that branch off of the rivers—you really have to get on the back roads and waterways in order to see Florida."

Interested in working on location like generations of artists before her, Barton added painting with acrylics to her repertoire. "At first, I would go out with *plein air* groups, and while the cama-raderie was enjoyable, I realized that I need to be alone when it comes to creating my art. So, even with the paintings, I still love to take photographs of the deep woods, marshes and secluded beach locations, somewhere where I feel safe and protected, and then I return to my studio to work in 'my zone' with my dogs as my only companions."

Reflecting this solitary view of nature, Barton's images bring the viewer into a personal dialogue with the land. "I want people to feel what I feel sitting in a boat with the low trees hanging over me. There is a sense of peace, a quiet and a beauty unlike any other, surrounded by wonderful natural vegetation changing color from season to season, even though most people don't think it does. There are amazing late afternoon reds and oranges in the green state of Florida—things that you don't see unless you spend time there."

Recently, Barton has moved to St. Augustine, expanding her vision to include the area's marine views, dunes of sea oats and lighthouse vistas. She delights in connecting her art with people, the last step in her dialogue with the Florida landscape. "When I create a work of art, it isn't finished for me until someone buys it or receives it as a gift. The audience's response is an important part of the process and it completes the circle for me to see an etching or a painting find a home."

Big Cypress National Park Acrylic on canvas 19 x 26"

Two in a Canoe Hand-colored etching 3½ x 5½"

Two Palms Hand-colored etching 5 x 3"

On the River Hand-colored etching 4½ x 2½″

Creekside Hand-colored etching 4½ x 2½″

JEAN ELLEN FITZPATRICK

Watercolors by Jean Ellen Fitzpatrick sweep the viewer into a hidden Florida of still marshes, lone herons and tranquil beauty. "I want to capture a mood, a fleeting combination of colors, textures and light," says Fitzpatrick, "to remind myself of the things that have really touched me and share them with others—beautiful springs, sandy white trails, hammocks and dunes, hilly or flat landscapes—I want to convey an appreciation of nature—the tranquility and power of such beauty."

The power of nature made its way into Fitzpatrick's life at an early age. Born in Orlando and raised in Gainesville, Fitzpatrick was always drawn to the water. "I like being near, on, in, under or over the water—fresh or salt water—the more natural the setting, the better. Originally, I intended to become a marine biologist, but changed my mind and studied graphic design instead." This different path eventually brought Fitzpatrick to watercolor, landscapes and the city of St. Augustine, where she combines her naturalist's perspective with her impressions of the ancient city. Working with light, color, composition and the ephemeral nature of her medium, Fitzpatrick records a moment in time, a bit of vanishing Florida. "I don't think I would have returned to Florida if not moved by what I see and feel living here. I have a native's natural instinct to try to preserve what we are in danger of losing. Development is taking over the pristine environment, fast wiping out natural habitat and much of what causes people to want to move to Florida in the first place. I often feature older architecture nestled within a beautiful natural setting, part of what makes the area so charming. It has seen much change in recent years, but the area still has a magical appeal."

Fitzpatrick's emotional connection with the outdoor world is evident in her paintings—scenes of the Mantanzas River, the ocean, the Intracoastal Waterway and Guana River State Park. "It is still relatively easy in Florida to get out and away, surrounding yourself in nature and the peace it affords. I paint what inspires me—a scene or subject that causes me to see something I want to capture in a painting. I enjoy the challenge of translating what I see and feel. Recently I have taken up fly-fishing and this is a focus in some of my paintings. I love the adventure of travel, especially when it takes me to places that are not so accessible."

Old Summer Haven—South of St. Augustine Watercolor 9⅞ x 13¾"

And from the Rain Fell Morning Watercolor 5⅜ x 13¾"

Flannigan's Island—A Scene from Crystal River Watercolor 4¼ x 9⅜

CICERO GREATHOUSE

Filled with saturated color and textural complexity, the paintings of Cicero Greathouse engage the viewer in a visual dialogue that is intense, melodic and absorbing. A citizen of the world, Greathouse was born in Fukuoka, Japan, moved frequently with his military family, and has continued to travel as an adult. He infuses his canvases with a sense of place that, despite their non-representational nature, offer sensory experiences from his many journeys that are gestural, lush and moving.

Florida is one of the many locations that has informed Greathouse's life and work. "Moving to Florida was my father's decision more than anything else. We moved here when he retired from the military and it was a shock. Everything from the weather to the landscape to my new peer group turned me upside down. However, I adapted and set out to become a Floridian. I swam at the beach and in springs, camped and hiked through the woods and pastures, and canoed rivers and streams. I grew to love the vast open Florida landscape and the coastal marshes."

Living in Florida for over forty years, Greathouse translated his love of the land into inspiration for his work. "The landscape of Florida, specifically the river flats of the St. Johns River and the coastal mangroves, has long been a reference point for my painting. The land-scape is vast and to capture the illusions and allusions of that vastness is a main point in my compositions. I try to capture phenomena like a mirage over a pasture or the way light and color shimmer over a highway—not in a representational way but as a visual metaphor. The painting is not the landscape explicitly but rather its allusion."

These painterly allusions resonate with emotional intensity for Greathouse. "Two of the primary ideas in my work are stillness and solitude—attributes of Florida's landscape that I fuse with my compositions. When I walk the river banks, ocean shores and prairies of Florida, there comes a settling in me that is a palpable sensation compelling me to reflection, brought about by the way space seems to expand in the stillness. This expansion is an intuition, a link in my process of making art. I do not wish to replicate nature but I do want to exhibit its effects on me as I paint. This is an interior discipline, one that is difficult at times to discuss or objectively describe. It is my hope that the viewer will look at my paintings as a metaphor of my visual observations."

Moving forward, Greathouse hopes to have a deeper understanding of living and art making. "Being an artist is, to me, more than mark making. It is a process of thought and reflection on my life and the condition around me."

Reflection on the St. Johns River Acrylic on canvas / diptych 72 x 120"

Playalinda Dunes Acrylic, colored pencil and pastels on canvas 72 x 54"

Reflection on Wekiwa Springs Acrylic on canvas 72 x 48"

Lake Harney for DK Acrylic, colored pencil and pastel on canvas 48 x 120"

RITA KENYON

Rita Kenyon's abstract paintings, elegant, lyrical and sensual, reflect a view of water, land and sky that was nurtured during her Florida childhood. "I was born here and have always lived in North Florida," says Kenyon. "As a child, I learned a deep appreciation for the beauty of ocean, river and creek. I learned to walk, barefoot on the beach, and the moss-draped ancient oaks and cypress provided the backdrop for all my family rituals. It is part of me—this magical place where water meets land."

Kenyon's emotional response to the magic of Florida is reflected in her approach to her subject. "As I paint, no matter the subject, I realize how connected I am to the expanse and abstraction of sky and water—of blues and greens—that it lives inside me. I also realize that translucent colors are the key; they allow me to reach in and unpeel the layers of mystery. And that it's the complexities, which at first can seem so daunting, that actually can guide and unlock the interpretation."

Intuitive and contemplative, Kenyon's interpretations are searches to uncover new meaning in familiar surroundings. "Florida's extraordinary landscape has that power—if we get quiet, very quiet, and listen—the seeming chaos has the power to reflect back the greater order. I look for the signs—the little glimmers from paradise—and hope for the courage to continue to examine, bear witness, and paint what I see—the secrets of nature where—and as—they hide."

These intensely personal meditations result in metaphors of expansive color, expressive brushwork and fleeting glimpses of imagery that draw the viewer into conversation with the artist. "I like to consider qualities not found in things but between things, and the natural elements in Florida inspire me to express the beauty found in the subtlest of forms. The horizon is a place in the distance, but I'm focused on the interplay between chaos and order, between color and shape. I look for uncommitted space and nature's breathtaking disorder, her unconfined composition, her unapologetic pattern—evasive, elusive, yet, clearly, perfect."

Kenyon's desire to explore the natural perfection of Florida is a journey of continual discovery for the artist. "I hope to continue to explore without interfering or forcing an outcome—to continue to wrestle with beauty and its meaning—and to not get too awestruck to enjoy life along the way."

Salt Marsh Acrylic 52 x 48″

Crescent Beach Acrylic 40 x 44"

Matanzas Inlet Acrylic 48 x 54″

McGirts Creek Acrylic 48 x 54″

Ocean & Sky Acrylic 52 x 52"

VICTOR KOWAL

Victor Kowal has always known he wanted to be an artist. "My father was an artist, and from the time I was a little boy, I knew it was the life for me. My father and my teachers encouraged me and I have never thought of doing anything else with my life."

A native of New Jersey, Kowal first came to Florida thirty years ago on a family vacation. "I didn't know that St. Augustine even existed. We had been to Orlando and decided to drive north along the coast to see the beach. I saw the city from the Bridge of Lions and it was like a mirage—like nothing else I had ever seen. I thought it would be a dream to move to a place like this and paint this beautiful city."

Kowal was a portrait painter in New Jersey and in St. Augustine, he painted "portraits" of buildings in the historic city. Commissioned to create views of subjects like the Cathedral Basilica, historic Flagler College, and the Casa Monica Hotel, Kowal developed highly-detailed, timeless compositions, a blend of Old Master technique and Surrealist atmospherics. "It's the romanticized version of the city that I like. All of my paintings take place during the early morning or evening, when the light casts long shadows and the shadows give the buildings a dreamlike look."

It was an easy jump from buildings to landscapes and it is in this genre that Kowal has found his artistic home. Enthralling, romantic idylls, the large canvases are filled with mesmerizing details and quiet, contemplative imagery. "I like to entice the viewer to enter the world I've created in my paintings, to get lost in the sublime beauty of nature. Off the beaten path, deep in the forests, Florida is like a magical place—mysterious, very primeval. When I'm working on a painting, I'm living in that place, and the viewer comes with me to experience the beauty and the fantasy of Florida." Working seven to nine hours a day, the smooth, glossy oil paintings often take a year for Kowal to complete. "I begin by laying in flat areas of color and then return to bring out the lights and shadows in the trees, then return again to fill in details and areas of visual interest, making decisions as I go."

With fourteen years' worth of commissions waiting for him, Kowal feels his future path is set. "I know where I am going for the next decade or more and that gives me the freedom to create. There is so much magic in St. Augustine that I could paint subjects here for a hundred years and still be inspired to continue."

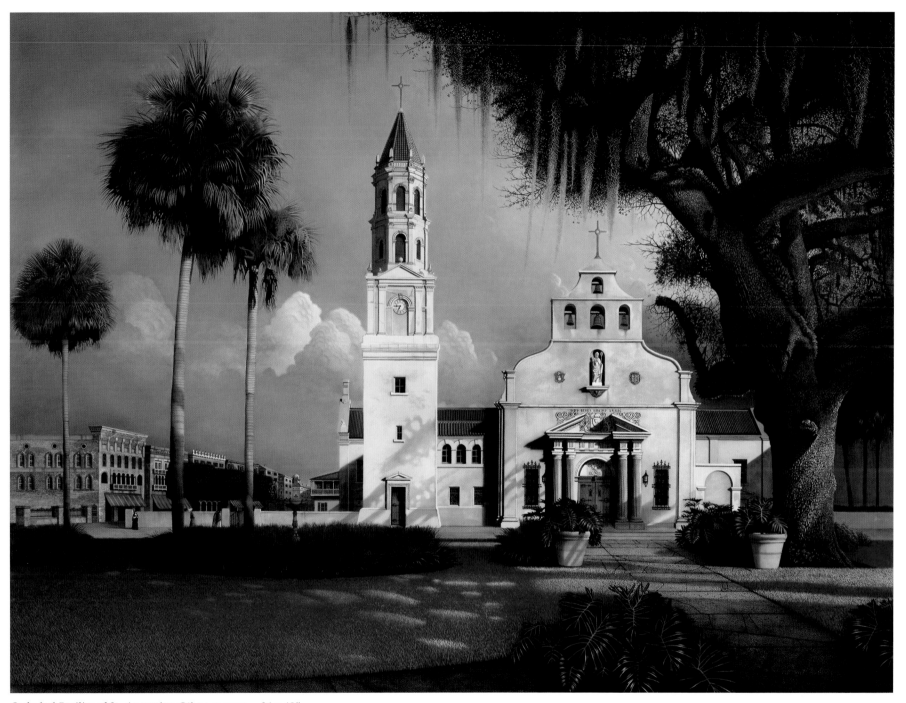

Cathedral Basilica of St. Augustine Oil on canvas 36 x 48"

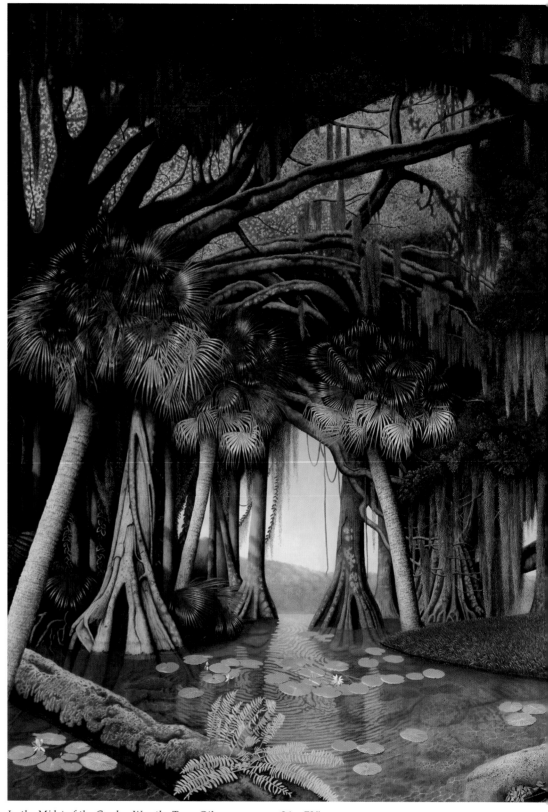

In the Midst of the Garden Was the Tree Oil on canvas 36 x 72"

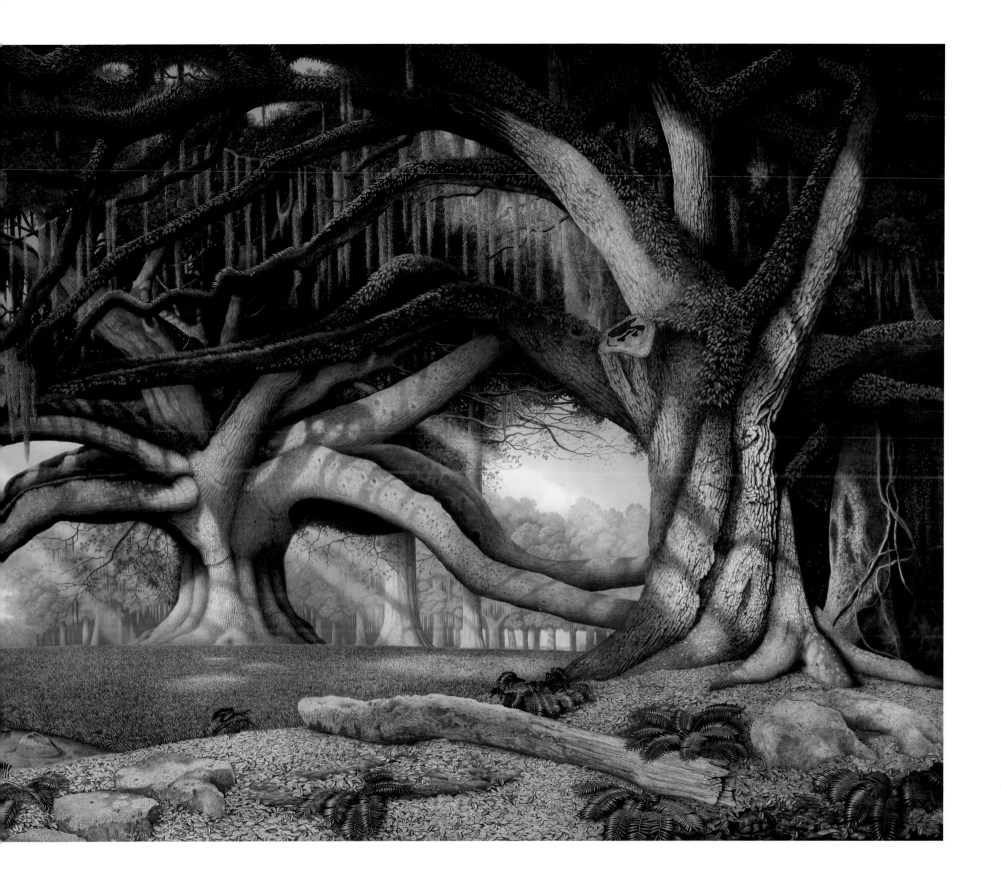

KARLENE McCONNELL

Karlene McConnell's vistas of marsh, sky and water are peaceful, contemplative views of the Florida environment that pulse with an underlying vibrancy. Lush and lyrical, they entice the viewer to enter a world of contrasts—still water and gentle breezes, expressive sunsets and flashes of colorful foliage. "My most recent paintings explore the horizontal bands of color that make up the Florida landscape," says McConnell. "Color and value have become more important than the actual subject matter. The sunlight that we experience in Florida and the way that it creates such varied color throughout the day has a great impact on my work."

With nature as her guide, McConnell explores the variety that is inherent in Florida's light and atmosphere while remaining mindful of the spiritual importance of the land. "My work has been described as serene, and I have also been told that it has a beautiful spirit. I hope to continue to capture the gesture of the subject, to convey a sense of the beauty of Florida, while creating a peaceful refuge for the viewer."

Born in Pittsfield, Massachusetts, McConnell moved to Florida in 1975. With a degree in Visual Arts Education from the University of Central Florida, McConnell has worked as an art teacher and a museum educator while pursuing her passion for painting, and this experience is reflected in her ability to convey the beauty of Florida to viewers. "I have had the advantage of being exposed to the creativity of many children and adults and I know that these experiences have enriched my own career as an artist. I hope that the future holds more opportunity to share and interact, and hope that my work will bring an appreciation of Florida to other artists and art enthusiasts."

The past few years have been an exciting time for McConnell as an artist. "I began painting with acrylics in 2005, after working with watercolors and other mediums for several years. I still enjoy the beauty of watercolor and the way the water and pigments create their own spontaneous organic forms, but working with acrylics has given me another avenue to travel as my style has evolved and become more tonal."

As McConnell's work continues to evolve, the constant will be her love of Florida and the beauty of the world around her. "I am most at home near the water and can't imagine living in a different environment. The fact that I can look out my kitchen window and see manatees swimming in my backyard or an alligator sunning itself on the bank of the river never gets old."

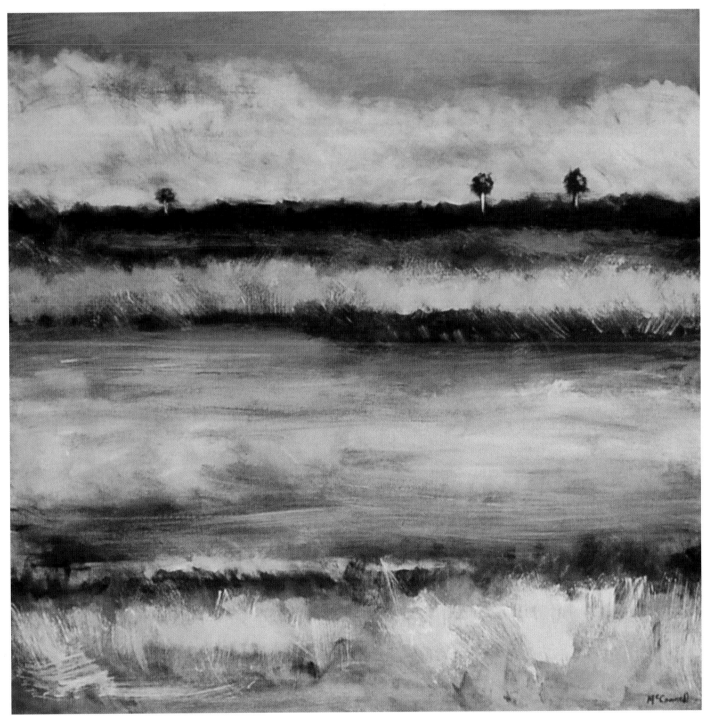

T's Painting Acrylic 36 x 36″

River's Edge #4 Acrylic 24 x 36"

Where the Herons Feed Acrylic 18 x 24"

SYDNEY McKENNA

Sydney McKenna has worked as a professional artist for more than twenty years. With a degree in Visual Arts from Eckerd College in St. Petersburg and graduate study at the Cortona, Italy campus of the University of Georgia, McKenna has created paintings that have been featured on the covers of numerous magazines and her works are included in corporate and private collections. Born in Santa Monica, California, McKenna first came to Florida as a child. "My father moved our family to the keys from Phoenix, Arizona when I was 11," says McKenna. "He started a tropical fish business and we five kids were his divers."

Living in many parts of the state, McKenna has experienced Florida's diversity and beauty. "In North Central Florida, I explored caves and scuba dived in springs. In the Sarasota area I lived on the Gulf Coast's calm beach. I've also had a cabin on the Myakka River—it was primitive and mystical; no electricity and miles from the hard road, deep in oak hammocks with sprawling tree trunks as big as an elephant. Now, in St. Augustine, I feel as though this area combines most of my favorite features of the state. I have lived many other places—California, Boston, New York, Italy—but my heart belongs to Florida."

This deep exploration and love of Florida's many environments has found its way into McKenna's paintings. "Florida is intrinsic in my subject matter. My early watercolors were more focused on the architecture, foliage and cast shadows that define the more tropical features of the state but during the last twelve years I made a transition to working in oils, and became fascinated with the humidity in Florida—something that I feel is at the root of Florida's character. Working in oil paint provided me enough time and control to blend and fuse the images of air and water."

The vast expanses of air and water in McKenna's magical landscapes work to transform quirky architectural features into elements of sublime beauty. "My compositions focus on the cycles of water and air in Florida. That is, while I may often show a water feature or treetops fed by the moisture in the air, my main focal point is usually that of water suspended in air. Now, when I do include any architecture, it is often fueled by my nostalgia for the Florida I remember as a child—sparse buildings and funky old bridges."

This mixing of air and water in McKenna's compositions has a resonance and impact that remains with the viewer. "The ethereal nature of clouds reminds me of the spark of life," says McKenna. "In them, I find a lifting of the physical into the spiritual. With this work, I know I'm doing what I was meant to do."

Danger Rock Oil on canvas 48 x 48″

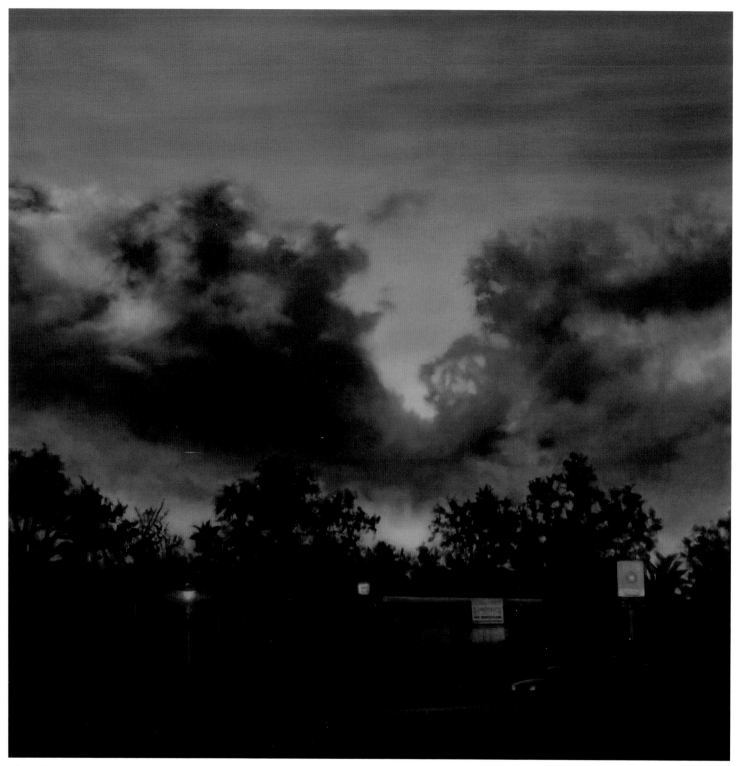

Blaze of Glory Oil on canvas 36 x 36"

Burnoff at Pellicer Oil on canvas 48 x 60"

GENE ROBERDS

Born in Missouri, Gene Roberds first visited Florida in the summer of 1947. "My family traveled around the circumference of the state in an old '36 Chevy," says Roberds, "stopping at all the free sites and staying in two dollar motels. While in St. Augustine, I told my mother, as I sat under a palm tree in front of what is now Flagler College, that I was going to live there one day. To me, Florida was an outpost or frontier, an exotic place of excitement, wonder and beauty—untamed wilderness, alligators, palm trees and snakes."

After graduate school at the University of Illinois, Roberds briefly found himself back in the state but soon left to teach at Murray State College in Kentucky and at the Minneapolis School of Art in Minnesota. "Minneapolis was a wonderful place to teach, but I never got warm during my four years in Minnesota. One day I remember saying out loud, 'That's it; I'm going back to Florida.' Six months later I had a position at Jacksonville University and have been here ever since."

Comfortably back in the sunshine, Roberds taught at JU for three years, and then opened a studio on St. George Street in St. Augustine, where he made etchings and engravings; he later took a position at The Florida School of the Arts. "It was a joy to teach there. I would take a group of students out on location three days a week and they had to perform like professional artists, completing a work that was finished, clean, and salable during each class period. I also worked during these times which soon developed into a love of working in *plein air*. Soon, I was painting watercolors on location and then working from them in the studio to paint large oils—a method I still use."

Roberds soon specialized in making the backwoods, unpopulated areas of Florida the focus of his paintings. "I would rather be in a small boat, painting in a swamp or creek, than in areas with too many people, souvenirs and concrete. I feel strongly about the documentary aspect of painting these areas that may not be here much longer. I translate the natural world into abstract lines, shapes, brush strokes and colors. I want viewers to see what I see on a realistic level and if possible, on an abstract level—to see the beauty of a site which I enhance with a manipulation of brush strokes, color, and composition. I would like viewers to sense or feel the abstract colors and brushstrokes in the painting while enjoying the beauty of the natural world."

Red Maples Oil on linen 60 x 84"

Lower Ocklawaha Oil on linen 48 x 80"

Blue Spring Canal Oil on linen 36 x 48"

OSCAR SENN

Artist Oscar Senn is a man of many talents. An author and illustrator of eight children's books, designer of toys, logos and posters, Senn worked as an award-winning advertising art director for agencies in New York and California before finding his artistic home as a realist painter. With diverse subject matter ranging from large format landscapes to surrealist images of American life, Senn sees his paintings as a link between the collector's heart and wild, unspeakable nature. Most often, the nature depicted is a vista that focuses on the changing moods of Florida. "Florida represents change to me," says Senn. "Whether it's the cloudscape or the beach, or the rivers or marshes, the state is not static for a second, but always becoming something else."

This interest in movement and change is evident in Senn's current work, a series of dramatic, closely-focused paintings of Florida's ocean surf, images that reflect the roiling power and intensity of the ocean. "I discovered the uniqueness of every wave, quite by accident, on a photo shoot at the beach. No matter how many pictures I took, each wave was different from the others, each with its own peculiar beauty. The combinations of form are infinite, uncountable and dwarf human understanding."

In all of his compositions, Senn is intent on interpreting nature rather than duplicating it. "I have always been a realist, but when I paint, I try to remember that I'm painting paint and not objects or things. The important thing is to make my stroke with intensity and complete abandon. There is no magic in duplicating nature, but in interpreting it. I cannot capture the nature of a single wave by thinking of the wave, but by following the color, value, and movement of the paint itself. I was not called by God to re-do what he has already done, but to make a new thing from something gone and dead. Truly, this is the miracle of art."

With work represented in local, state and national collections, Senn is always looking towards the future with interest and excitement. "My long-distance goal is mastery—to develop my skills and refine my vision. I think of my paintings as sacred portals, fetishes or gifts of the spirit. I want them to become windows overlooking something eternal and indefinable—a magical act that can turn the corner of a home into a refuge, a place of domestic pilgrimage."

Wedding Cake Oil on canvas 36 x 36"

Amber Dawn Oil on canvas 24 x 18″

Shallow Sea Oil on canvas 48 x 24″

KENT SULLIVAN

Kent Sullivan has been painting traditional landscapes for thirty years. Born in Nebraska, Sullivan spent his childhood in Colorado and moved to Florida as an adult. "I was about thirty when my wife and I decided to venture out and make a living in art," says Sullivan. "I was originally interested in coming to Florida to join an artists' touring group that started exhibiting in Miami in October and did shows in malls all the way up the east coast into the summer. I had no idea what I was getting into. I did three shows, sold a few paintings, but got as far as Orlando when I realized it wasn't for me."

Living in Florida made a difference in the way Sullivan sees the land and approaches landscape painting. "At first blush Florida just seemed flat for someone who grew up spending much of his life in the mountains. But when I began to look, I saw that it is lush and it is varied, with water and humidity as dominant features. Soon I saw that skies, clouds, sunsets, sunrises, palms, live oaks, beaches, and marshes are as varied as their counterparts in the west. Although I travel a lot around the southeast to gain new perspectives on landscape themes, Florida is home and I see my subject matter everywhere."

Florida appears in Sullivan's work as an arcadia, a golden land of promise and beauty. Reminiscent of the nineteenth-century painters of the Hudson River School, Sullivan creates landscapes that evoke an emotional response in the viewer. "I make compositions that reflect what I feel about what I see. I do not necessarily include a lot of man-made structures, but I don't pretend they are not there either. A road, a boat, a bridge may actually help romanticize a painting. I'm somewhere between a romantic painter and a realist. That is the only way I can seem to describe the intensity of a scene."

This emotional response to a work of art and to the land is what Sullivan hopes to convey to his viewers. "I want people to have a sense of awe, the same sense of awe I experienced when I first saw the scene while walking along the beach, or peeking through the trees, or being stunned by a sunset. I am committed to bringing the outside world inside—not just inside the building, but inside the heart. As people made in the likeness of God we all have an appreciation for creativity and beauty. To the extent that I can stun with beauty, I have achieved what I set out to do."

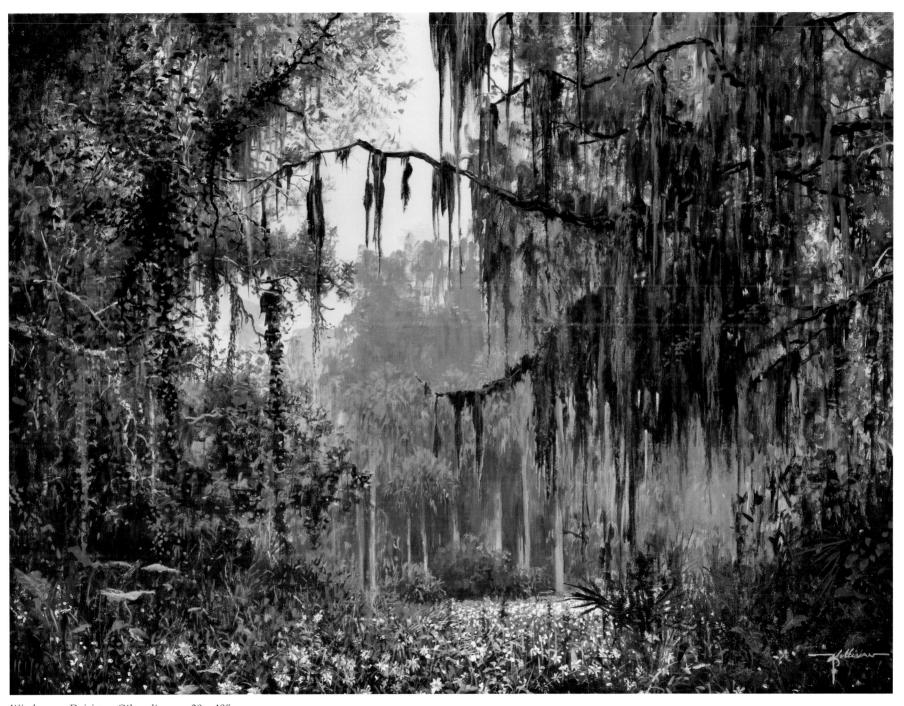

Windermere Daisies Oil on linen 30 x 40"

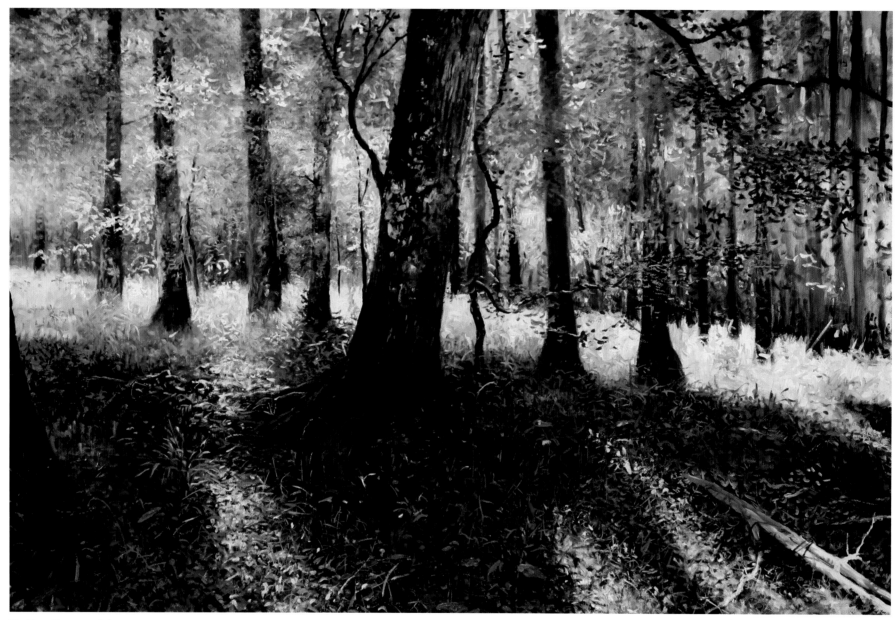

Big Econ Forest Oil on canvas 30 x 40"

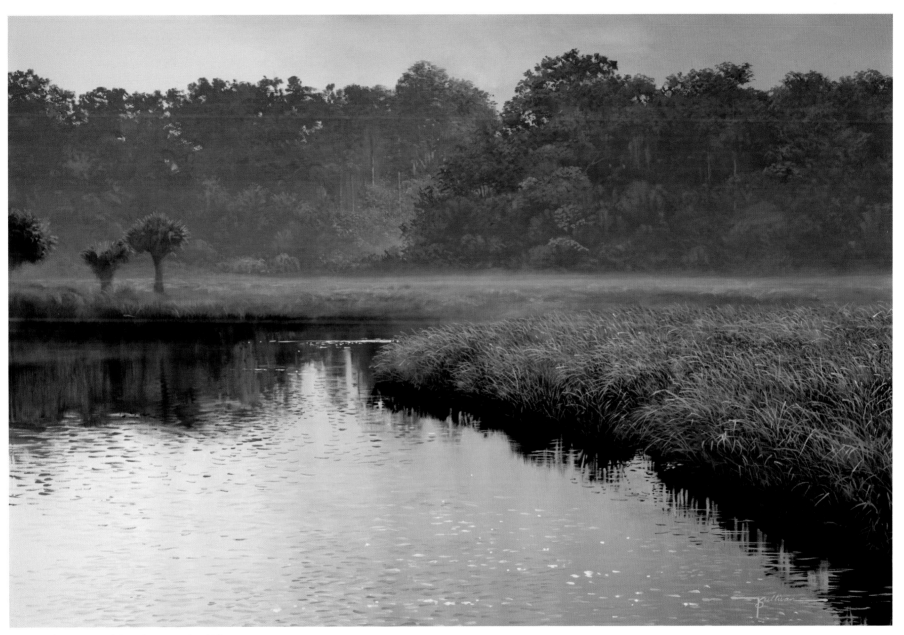

Foggy Pelicer Bog Oil on linen 30 x 40"

TRISH THOMPSON

Trish Thompson sees the world in terms of composition. Articulate, scholarly and insightful, Thompson's natural gift for balance and style is evident in both her life and her art—multi-layered, quilt-like creations that reflect Thompson's interest in multiple levels of meaning and her love of process and experimentation.

Thompson was born in the Florida Panhandle, in Panama City. Educated at Florida State University, she briefly lived in California as a child and studied painting in Italy before returning to her home state. "I traveled a lot," says Thompson, "but always came back to Florida. I miss the water whenever I go somewhere else. I am transfixed by the sky and the water. They are a different texture and color every minute and I love the non-objective color distribution I see there—all transparency and reflective surfaces."

Currently a college professor, Thompson has also worked as a prep school teacher, museum educator, advertising designer, arts consultant and exhibiting artist. A potter and sculptor by training, Thompson experimented with printmaking and painting in graduate school, and it was with painting that she found her home. "After my children were born, I needed to work two-dimensionally—and faster—so I started painting in acrylics. My paintings were non-representational. We have always lived near the water and it was natural to pretend that I was painting riverscapes, since that's what I saw every day. As I started teaching, I taught still life as subject matter, but the main subject matter in my paintings has always been texture, color and building the surface. That's what I love about every sunset, and that's what comes out in my work, the texture and color of the sky and water. My work is to love texture and color and play with it, and maybe to evoke the feeling of a Florida view."

Using a wide variety of media, Thompson works to create compositions that are personal yet enigmatic, intuitive yet cerebral, a duality that reflects her fascination with form and light and her passion for her process. "When I paint, I don't really think about conveying a message to a viewer. That makes me focus on the finished piece. I just paint and think about the process. If it works, great; if it doesn't, it gets destroyed and I do more. My ultimate goal is to always convey that this is a painting. It is made of texture and color on a two-dimensional support. It represents a particular set of decisions about placement, color and texture made by the painter. Somebody made it. It is not the sky and the water, although maybe is inspired by that. The subject matter is always the painting itself."

Beginning with grid-like constructions and moving to a wetter, more painterly style, Thompson currently is combining these earlier styles into complex, surface-centered meditations on color and texture. "My husband calls it my 'fusion' series. We'll see where it leads me."

Yellow Palm Bank—Lake Beresford, DeLand Acrylic on canvas 14 x 11"

Blue Sky—Lake Beresford, DeLand Acrylic on canvas 12 x 12"

Landscape with Floating Squares Acrylic on wood 12½ x 17"

FLORIDIANS AND THEIR NEIGHBORHOODS

In the tradition of many Latin American artists before her, Maribel Angel is a storyteller. "My paintings are layered with history and emotion," says Angel, "qualities that come through the surface to tell of a world that lives deep in my subconscious. My family is from Colombia and the color and folklore of my Latin heritage comes through in my paintings. There's something about the way we see that is unique and allows the imagination to take flight. When I pick up a brush, my hope is to tell stories with paint that will enchant viewers."

Angel arrived in Florida as an adult and became enchanted with St. Augustine. "I flew south when it was time to leave the nest, just like a bird looking for warmer weather. My first stop was St. Augustine, where its Spanish history, colonial architecture, tropical climate and lush green environment welcomed me. St. Augustine has an aging elegance and a patina of its own, weathered by centuries of bright sun. I have a deep appreciation of its eroded, historical beauty, and I try to capture this in my paintings. The process that I use to texture and layer paint blends well with the layers of time I find here."

Living on a lake where she can enjoy Florida's natural beauty, Angel is inspired by her surroundings. "I see beauty in the colors, patterns, textures, shapes and shadows here, and beauty in the sweet fragrance of orange blossoms and jasmine in the air. But the most fascinating discovery to me is the way the light in Florida plays with colors. Light dapples through the leaves, makes colors bounce, and at times you can see a glow and even feel the vibrant colors buzzing in the heat of the day. Living in Florida has certainly opened my eyes and awakened my senses."

Surrounded by beauty, Angel also finds romance and poetry in Florida's landscape. "I don't paint Florida as I see it, but rather convey how I feel it. Inspired by my surroundings I pick up a brush to say things with paint and color that I couldn't say any other way. My works are never planned or controlled; they simply start out to note color, shapes or a sense of movement, while trying to keep a natural harmony in the design as well as a feeling of honesty. When complete, my paintings become expressions of living in Florida. As my work evolves, my intention is for my paintings to connect the viewer to the soul of a place, a memory or a time and to stimulate their imaginations visually."

Sun Dappled Days Acrylic 24 x 24"

Odette Acrylic 24 x 24"

Flutter in the Citrus Tree Acrylic 24 x 24"

Filled with twists, turns and contradictions, Gary Bolding's paintings are visual dialogues that engage the viewer in surprising conversation. Working in a style that is rich with detail, Bolding combines pop culture motifs and iconic art images to create philosophical discourses that are equal parts art history lesson, op-ed commentary and stand up routine.

With a background that is as diverse as his art, Bolding, born in El Dorado, Arkansas, has lived in Arkansas, Tennessee and Texas before settling for many years in New York City. He arrived in DeLand, Florida in 1989 to take a teaching position at Stetson University where he is currently chairperson of the art department. "My wife Jane and I wanted to move to a place that was geographically different from anywhere we had lived before," says Bolding, "somewhere that had either palm trees or desert. Palm trees won."

Surrounded by live oak trees draped with Spanish moss, Bolding has found that Florida is a good home base for his creative work. "I live in a rural area on a piece of land that was a derelict grapefruit grove. This Florida is far different from the one that tourists typically see." That being said, Bolding does not use the rural landscape in his art but rather focuses on the conceptual landscape around him. "If Florida has wormed its way into my imagery, it has been as a pop culture reference that reflects some aspect of my experience. For someone who is interested in portraying the rich weirdness of contemporary life, Florida is a great source of inspiration. The war here between the natural and the artificial is pretty intoxicating. I don't know that I would have painted *The Ascension of Christ Over Pizza Hut* if I had stayed in Manhattan."

Working in a classical, considered manner, Bolding gives physical form to his ideas through a process of constant revision and refinement of the initial impulses that cause him to start a painting in the first place. "The image evolves as my understanding of what's going on in the painting becomes clearer. Sometimes additions or deletions are based on formal needs, and sometimes they have to do with the implied narrative of the picture. The best works are usually ones that reveal themselves to me gradually. It's as if my inspiration comes on the installment plan."

In search of fresh ideas and artistic dialogue, Bolding works to keep himself connected to the larger art world while enjoying the isolation of his home in central Florida. "There are few distractions to tempt me away from painting. The downside of this is that I am also rather isolated from the stimulation of an extensive art community, and it is necessary to travel a great deal in order to keep abreast of what's going on in the art world."

Where does Bolding see his art taking him in the future? "To the grave," he replied.

Double Self-Portrait Oil on linen 40 x 34"

Man with Flaming Wiener Oil on linen 42 x 56″

Clipping Man Oil on linen 30 x 40"

O.D.I.O. No. 3XL Acrylic on canvas 80 x 120"

S.P.F.A.H. No. 1XL Acrylic, oil stick, and oil on canvas 80 x 120"

Rainey Dimmitt is passionate about her work as an artist, a passion that is evident in her expressive portraits of seated figures. Thoughtful and elegant, these softly lit and subtly colored characters appear as fully-realized personalities. Relaxed and comfortable, they seem poised to engage the viewer in conversation, ready to convey the narratives of their lives.

Dimmitt's personal narrative begins in Virginia. "My family on my father's side were long-time residents of Virginia, having received a land grant from the King of England in the 1700s. I was settled there but as the circumstances of my life changed, I began to feel the never-before need to explore other areas of the country. When my brother and his family moved to the Daytona area, I came along for the journey, remained, and found a new home and life in Florida." Now living in Ormond Beach, Dimmitt found a sense of belonging in her adopted state. "I discovered a similarity of feeling among residents whose families have resided in Florida for many generations as mine in Virginia did—a love of the land, an awareness of the changing times as it has affected the area."

Parlaying this sense of belonging into her art, Dimmitt creates large canvases ranging in subject matter from figurative portraits to bold, expressive landscapes. In all of these, Florida figures prominently. "My conscious choice is to depict this Florida world, giving strong freedom to my creative impulses. I paint the world around me—the interior of my home, the surrounding lot which we've left as natural as possible, the city streets, older buildings along the river in Ormond Beach. I am also involved quite intensely in figurative work, working solely from life, focusing primarily on capturing emotional aspects rather than an exact physical likeness of my subjects. I assume liberty with color and form while maintaining a semblance of similarity to my subject— a 'subjective realism.'"

Dimmitt's focus on establishing a sense of realism as well as an expressive, artistic liberty is present from the inception of a work of art. "When I begin a painting, I choose that which stirs excitement or fascination in me. It's more of an emotional decision than an intellectual one. The work soon begins to have an inner life of its own and I become caught up in its unfolding, as though I am but a tool of the artwork. I work until the piece feels whole, balanced and 'right' in all aspects. In process, I often begin with a quick oil sketch to establish relationship of forms in space followed by blocking in areas, then proceeding from gross to detail with constant refinement as the work progresses."

Dimmitt's progress as an artist is ever-evolving and will continue to be shaped and sparked by the world around her. "My art will change as I change in life. Florida has, and will continue to allow, an abundant, vital source of inspiration."

The Musicians Oil on linen 50 x 39¾"

All That Jazz Oil on linen 58 x 42"

Return to Eden Oil on linen 58 x 42½″

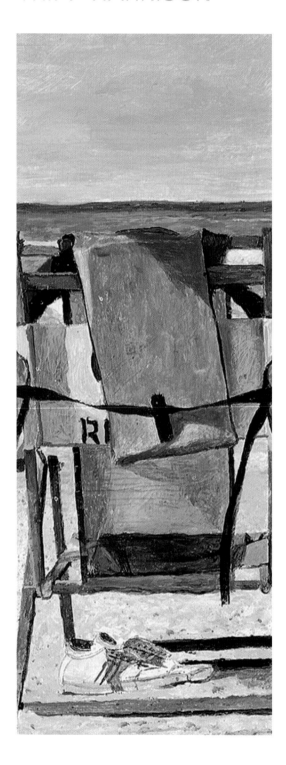

Growing up in Miami on Biscayne Bay, Tripp Harrison's childhood memories of water, boating and sun are revealed in his paintings. "My heart has always been in Florida," says Harrison, "and painting scenes of the state is a joy for me, a way of reliving the experiences that have made me happy to be a Floridian. I grew up around the water—fishing and diving— and I have always been drawn to subject matter that reflects the happiness I've found there."

Now living in St. Augustine, Harrison discovered his love of painting as a college student in Atlanta. "I studied business and accounting in college and wasn't interested in art until my parents became collectors. I was attracted to the paintings I saw at home, enrolled in art classes, fell in love with painting and quit school. I apprenticed with an artist in Atlanta for two years, painting on location and in the studio. I was hooked. Painting for me is now a craving, something that I have to do and that I love."

Inspired by Andrew Wyeth, and by artists who painted in Florida like Winslow Homer, George Inness and Stephen Scott Young, Harrison develops his compositions slowly and carefully. "I work in pencil, watercolor, acrylic and oil. I begin first by sketching and will then make small watercolor or acrylic studies to work out my composition. Whether the final work is small and intimate or large-scale, I begin with messy, loose brushwork and use a lot of gray, burnt umber, white and blue, building up layers of transparency and value. I try not to get into color too quickly, bringing it in at the end. I'm not a formula person, but rather a problem-solver, changing and moving as the process unfolds. Eventually, the composition, color and balance come together to create something that evokes an emotion, a feeling for the viewer."

Developing his unique vision and style as an artist, Harrison always returns to Florida's waterways as a central element in his compositions, whether working on location, from memory or from photographs. "I start with a specific subject—a boat, a cottage on the beach, an architectural element, and slowly build everything else around it. I try to create a reality that a viewer can walk into—a peaceful, nostalgic place—that reflects the heritage that I have as a Floridian."

Wherever he works, Florida will remain a constant source of inspiration for Harrison. "I collect antique Daguerreotypes and photographs and have recently become interested in views of coastal New England. It's an area that has a mood and emotion that is at once different yet similar to Florida. I plan to spend some time working there, but I will never leave Florida. It's my life."

Attitude Adjustment Oil on panel 9 x 12"

Reflections of Twilight Oil on canvas 24 x 36″

Island Hideaway Oil on canvas 26 x 52"

JANE LESTER

Reminiscent of hand-colored post cards from an earlier time, Jane Lester's photographs capture the essence of the Florida aesthetic. "What makes a landscape evocative of a place is the light—light is what makes the landscape a Florida landscape. I like to quote Joel Meyerowitz who said 'Light gives dignity and a sense of the eternal to the commonplace.' The poetic quality of light is what makes photography art, or one of the ways that photography can be art. Capturing that quality is what I try to do with my photographs." Spare, economical, yet filled with seemingly familiar details that evoke warmth and intimacy, Lester uses this aesthetic to create photographs of contemporary Florida that give the viewer a glimpse into the collective history of her adopted state.

Born in Avondale Estates, Georgia, Lester moved to Jacksonville, Florida in the early years of her marriage. After raising a family of four children, Lester graduated from the University of North Florida with a degree in painting, and soon turned what was then her hobby of into a full-time job. "I took photography my last semester because I thought that every artist should know how to use a camera. I didn't even know how to put film into a camera at the time. After that, I had an agent who got me commissions to photograph buildings and landscapes for clients, and I traveled around the state to photograph local landmarks or places of interest to those who commissioned them. Most of my landscapes were commissions too. This led to shows and a demand for more work."

Building on her success as a photographer, Lester soon was winning awards and exhibiting her work regularly. Throughout, she has used the lessons learned in her painting studies to create her ethereal compositions. "The composing process is mostly instinctive with photography as in painting. Sometimes you are struck by 'that certain cast of light,' or the look of an old building. Something about those old buildings just appealed to me. It wasn't until later that I saw a painting by Edward Hopper with almost the same look. There's just a radiance about life that I think may be somewhat universal. I try to communicate that as my personal vision."

Most recently, Lester has brought vision and her art full circle and returned to painting. "I realized that I had said about everything I had to say in that medium, and I returned to painting full time although I still use photography in my paintings on occasion." Working with still life, Lester creates floral-based compositions that are reminiscent of Asian screen paintings. "I want my work to move toward the elegant understatement of Oriental Art. It's all an adventure."

Front Porch, Plant Hotel (University of Florida) Hand colored gelatin silver prints 16 x 20"

Forsythe Street, Jacksonville, FL Hand colored gelatin silver prints 20 x 16"

Greater Union Baptist Church, DeLand, FL Hand colored gelatin silver prints 16 x 20"

Theo Lotz is a painter who sees the landscape of Florida in the faces before him. "The Florida of my childhood has largely been lost to development," says Lotz. "I sometimes barely recognize vast areas of town that I haven't visited in a while—where there were once pastures or orange groves or woods there are now housing developments. Perhaps because I no longer have a connection to that remembered landscape, I have rooted my sense of Place in the connections to the people who are here. The faces of my friends and family have become what Florida means to me now. When I'm painting a head, it is very much like exploring a landscape, and in that way, my recent paintings are really *all* about Florida."

With graduate study at the Pennsylvania Academy of Fine Arts in Philadelphia and the Royal College of Art in London, Lotz comes from a family of artists with an international outlook. But wherever Lotz has lived—Austria, Brazil, Scotland, England, Louisiana, Pennsylvania—Florida has never been far from his mind. "Although I was born in Vienna, I was raised in Florida and have always felt that Florida was home. It is an interesting place for an artist. There is a quality of light here that is very intense, almost blinding. The light changes very quickly, making every glimpse of a head different from the last one. That keeps the painting process exciting—being just behind capturing the image before it changes again."

In his portraits, Lotz captures the image and essence of a person while developing an energetic and dynamic composition. "I want to convey something of the relationship I have with subjects—the process of looking intensely at their faces and about their experience of sitting for extended periods. It's a rare treat that portrait painters have: to be able to stare at people, and to constantly see them anew. The 'likeness' is one thing—of course, I want it to look like the sitter—but that's a relatively easy thing to do. I want the paint itself—its application, its energy, its nuance—to be as important as the likeness. Rima Jabbur, Curator at the Crealdé School in Winter Park, described my paintings as 'being on the edge of fragmenting, much the way a digital image falls apart.' I love that—the idea of creating images that are about to pixelate and vanish—a glimpse of reality before it changes."

Self I Oil on panel 12 x 10″

Tony, 2007 Oil on canvas 14 x 11″

Marky P. Oil on canvas 30 x 24"

MELISSA MASON

Visitors to Florida often look for palm trees, beaches and oranges as symbols of the state. When Melissa Mason arrived twenty years ago from Cumberland, Maryland, she was in search of employment and along the way, found Florida's horse country. "I had only visited Florida once in the year before moving here," says Mason, "and it was very different from everything I had ever known—I even thought the first palm tree I saw was fake because it was so amazingly different—but Florida is one of the top three states with the highest horse populations. There is every breed of horse and discipline of riding in the state."

An avid rider, Mason has channeled her passion for horses into her art. "My first love, as long as I can remember, has always been horses but I never had one as a child. When I arrived in Florida, I was fresh out of a two-year college and worked in various clerical jobs over the years. I got my first horse when I was twenty-seven and soon after, I returned to school to become a nurse but continued to ride and participate in barrel racing. I was always creative but had never produced art professionally. When I was thirty-five, I decided that I wanted to start painting. I knew that sitting around thinking and reading about art wasn't going to get me anywhere, and I realized that if I was going to be an artist, I had to get going. The subject matter was obvious from the start."

Florida is filled with horses, and with bright, sunny days that find their way into Mason's compositions. "I would say that my use of color is reflective of the Florida light and heat. I love the intense light on my subject matter that the endlessly sunny days in Florida offer. As I evolve as a painter, I want to convey the beauty, power, and movement of the horse, without painting every detail of the horse. I use acrylic paints, which are extremely versatile and work well with my loose painting style, to convey movement. My compositions are usually closely cropped to produce an intimate experience for the viewer. I want the viewer to be drawn into the movement and moment in time, and to experience the tension, movement, and look in the horse's eye. Living here, I am never at a loss for inspiration for my next painting."

Round-up Acrylic 52 x 42"

Tequila Sunrise Acrylic 30 x 48"

Ocala Gold Acrylic 18 x 24"

Karen Sheridan's paintings of St. Augustine and Key West pop with color and affection for her surroundings. Focusing on the historical architecture of the two cities, Sheridan looks at cozy bungalows, Victorian cottages and weathered beach houses with a writer's eye and a painter's touch, and weaves the two into intriguing narratives of time and place. "My paintings are considered to be architectural landscapes," says Sheridan, "but it all started with color and light. I was struck by the way the sun hit the sides of one old shingled house and was overwhelmed by the challenge of trying to mix the colors that the sun and shade were making—the warms, the cools, the intensity of the light. While focusing on the color, I was struck by the individual style and spirit of the home. These homes are the hostesses of history and embody the spirit of the Florida lifestyle."

The Florida lifestyle is what first attracted Sheridan to living in the state. "Twenty years ago, when I first set out to become and artist, I was living in Boston and the life there for an artist was very difficult. I had a seasonal business in Faneuil Hall Market, making and selling one-of-a-kind custom-decorated straw hats for the millions of tourists there. I would work in the Market all summer and then hibernate and paint all winter. Ten years ago, I had the good fortune to rent a studio on the Intracoastal in Ft. Lauderdale, and that winter I fell in love with Florida. I fell in love with the gentleness of the climate, the warmth of the sunshine, the colors and the casual life style. As a New England girl, I never imagined living here and I am so happy to be a productive working artist in the Sunshine State."

This love of place and of the natural lighting, beauty and what she calls the "soul of people who love art" that she finds in the state is evident in Sheridan's compositions. "When working on a piece, I am in a battle to try and capture the elements of color, structure, light, shade, value, time, heart and soul of my subjects, the buildings that dance in motion with the sunlight, but I am always aware of the fun I am having and aware of the pioneer spirit in my surroundings. I am here, and for the first time I am where I am supposed to be, painting what I am supposed to paint in the way I am meant to paint and I hope that shows in my work."

Bungalow Baby Oil on masonite 24 x 30"

Coconuts and Cream Oil on masonite 24 x 36"

Moon Shadow Oil on masonite 36 x 36"

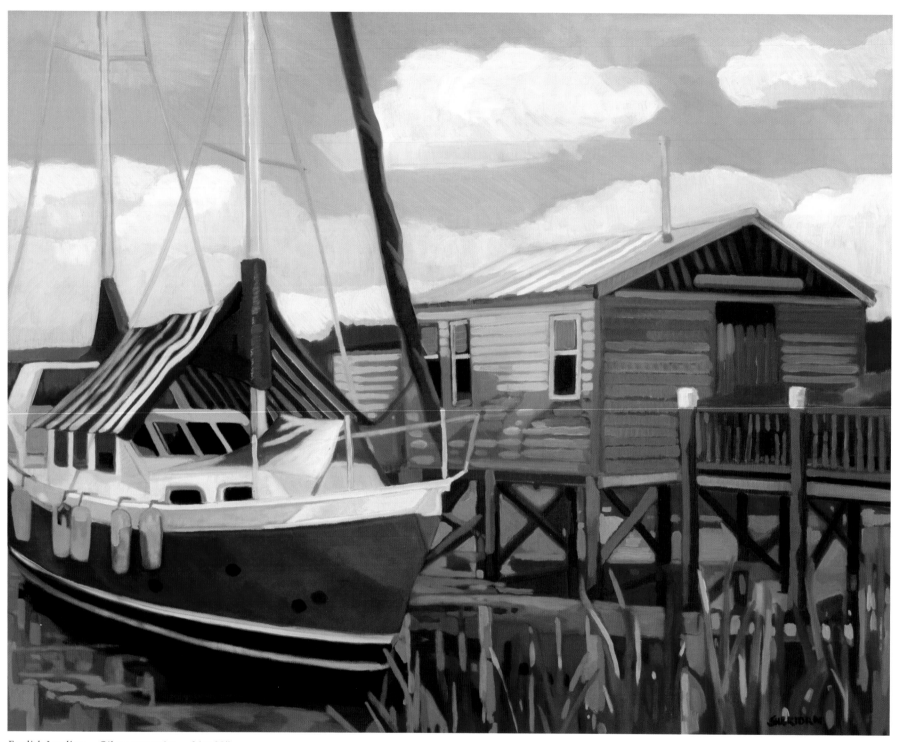

English Landing Oil on masonite 24 x 30"

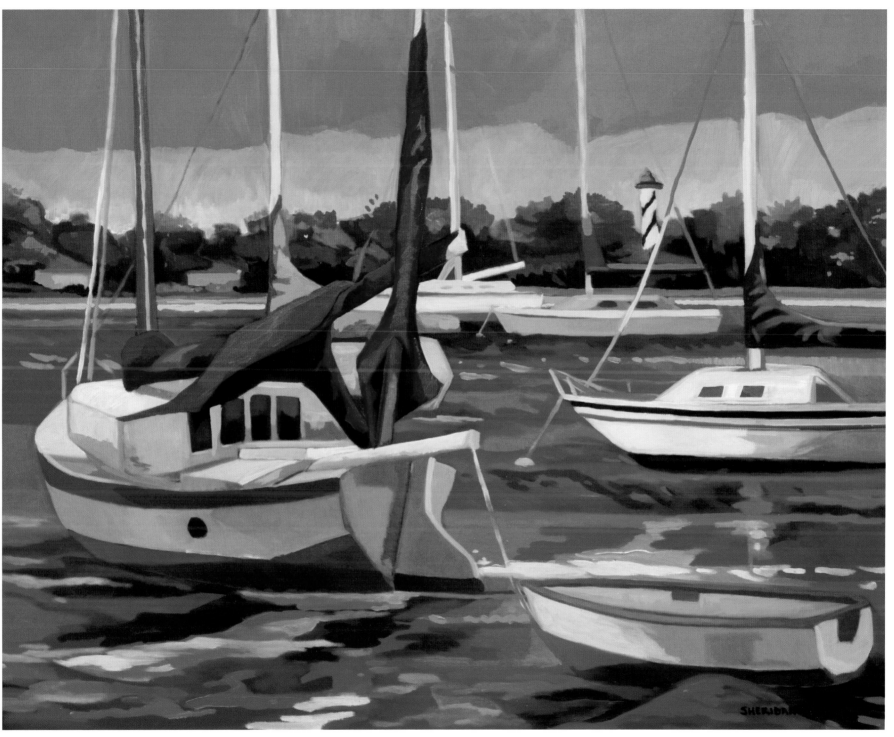

Oh My Maya Oil on masonite 24 x 30"

BARBARA SORENSEN

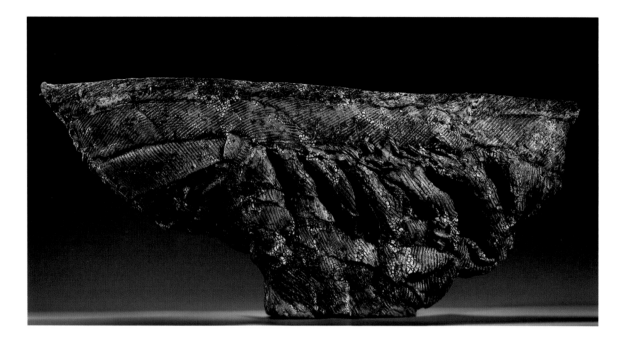

Majestic, symbolic, primordial and powerful, Barbara Sorensen's sculptures connect the viewer to geological formations of the earth and tendrils of human history. Imposing presences, the forms are often grouped in installations where they appear to be one with the land yet evoke a human presence, a duality that is intentional. "My sculptures are about the figure, the landscape and how these relate to each other in the environment," says Sorensen. "Speaking of energy and transformation, I find these strong forms to be a metaphor of how life ebbs and flows, how choices and changes are informed by Nature."

Born in Kansas City and raised in Wisconsin, Sorensen now divides her time between Colorado and Florida. "I moved to Florida thirty years ago to live in a climate where I could experience the outdoor environment the majority of my days. Living in Florida has heightened my ability to encounter and comprehend the landscape and has allowed me to tap into the subtle energies of nature and self."

A student of Don Reitz' at the University of Wisconsin in Madison, Sorensen has also studied with master teachers Dan Gundersen, Peter Voulkos, Rudy Autio, and Paul Soldner. While she works in a variety of media—bronze, clay, aluminum and resins—Sorensen seems most at home with the earthy naturalism of stoneware. "Many of my pieces are formed in clay, the most basic element of the earth. I build by stacking and joining the clay as I move upward to create layers of antiquity, layers of time, layers of myself. Since my work is expressionistic, it is always made on a subconscious level and there is a primal force occurring as the forms emerge from the clay. I let the process lead me and each mark I make informs the next."

Sorensen's installations and sculptures serve as metaphors for her intensely personal view of the environment. "I desire to make people aware of their surroundings and my sculptures become spaces to experience. I create places and environments for people to think, and a place where the viewer can begin a dialogue with my work and with the environment I am interpreting. In *Willows*, I see stalks of branches moved by ocean breezes; the *Nymph* as Gaea, goddess of the earth, repeats the swell of sand dunes and the life giving outflow of the waters; the exterior of the *Boat* reflects the undulations of the landscape in its topographical elevations and uneven textures."

Sorensen travels extensively, most recently to New Zealand and Australia, in search of new environments—new muses—to nourish and invigorate her artistic quest. "I want to continue to see the landscape from different viewpoints and to find new materials to express what I see, to challenge me to move to new levels of technique and attitude."

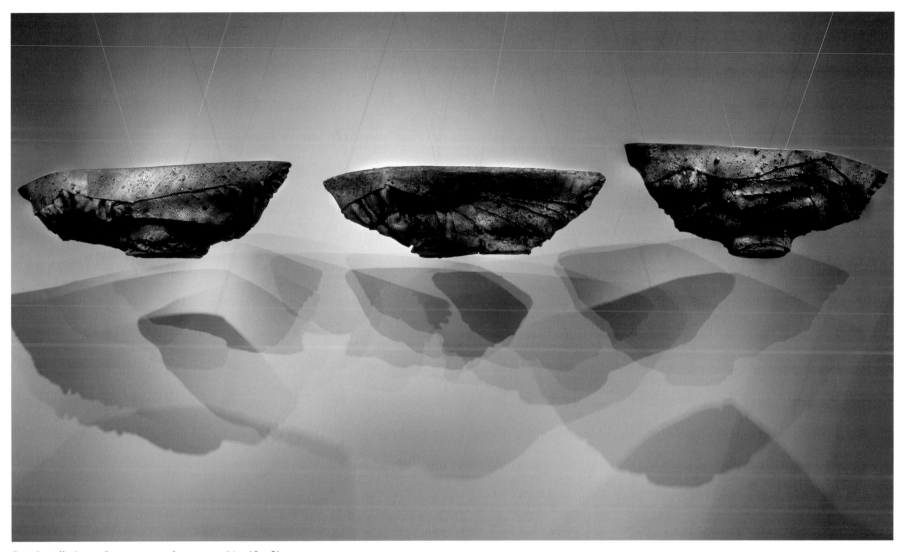

Boat Installation Stoneware and stones 16 x 13 x 2'

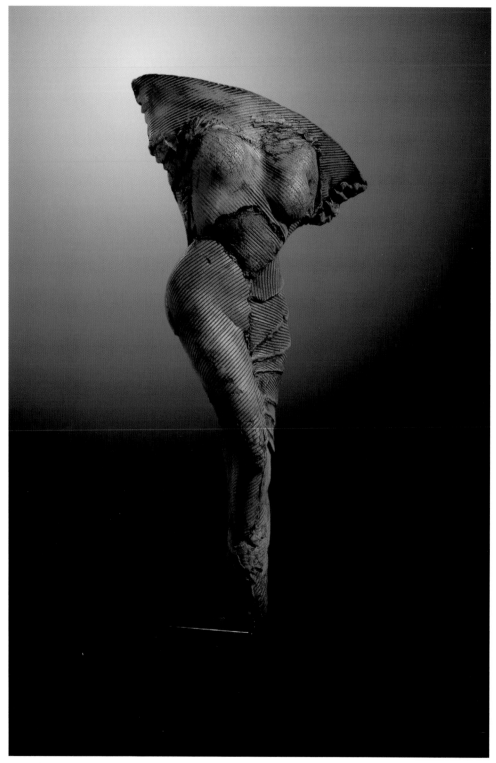

Nymph II Stoneware 41 x 22 x 13½"

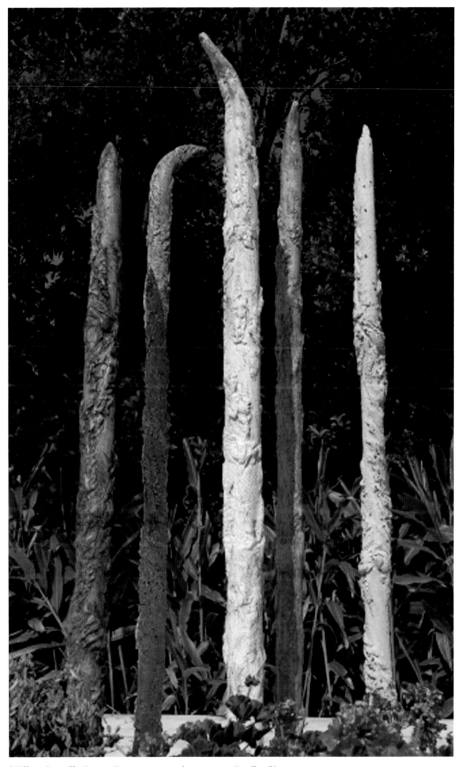

Willow Installation Stoneware and stones 8 x 7 x 5′

WENDY TATTER

Salty air, tumbling waves, dappled sunshine and historic monuments—Wendy Tatter's batik compositions bring viewers on a sensory tour of her Northeast Florida world. "I love to paint the old houses and streets of St. Augustine," says Tatter. "So many are being changed and modernized that it seems important to have some of the old places saved in that way. I also love the beach and the hammock areas—the colors of the water and the tropical plants that grow here. I want viewers to get a feeling for the way I see things. I want the colors to make them smile and the painting to make them feel the movement of the moment."

Raised in Severna Park, Maryland, Tatter studied art briefly at Virginia Commonwealth University and the Maryland Institute of Art. It was a workshop at the Instituto Allende in San Miguel de Allende, Mexico, however, that changed the course of her artistic life. "In Mexico I was introduced to the art of batik. I was so intrigued with the almost backward way of creating a design, that I've been working in the medium ever since." After living and working in the Caribbean and Central and South America, settling in St. Augustine seemed natural. "I came to Florida with my husband in 1986, mainly because he was a University of Florida graduate and had spent his summers in St. Augustine. With plants, beach and history, I found that St. Augustine has some of that same tropical feel as the Caribbean."

The centuries-old Javanese fabric technique allows Tatter to create works that are fluid, fresh and spontaneous, a spontaneity that belies the intricacy and exacting nature of her process. "Batik is the technique of making designs with molten wax and dyes. The word itself is Javanese and means 'writing and drawing with wax.' To create a batik, a mixture of wax and paraffin is applied to cloth with a paintbrush or a tool called a *tjant*, then dyed. The wax resists the dye bath, beginning the design. This process is repeated with more layers of wax and more dye baths until the composition is created."

Exhibiting widely and the recipient of numerous awards, Tatter has a studio in the historic city where visitors can step into the world she creates in her paintings. "My batiks often reflect the people and places I've enjoyed in my travels and life. I have a wonderful, busy shop in Saint Augustine and am having the best time just meeting the people who come by and enjoy my work."

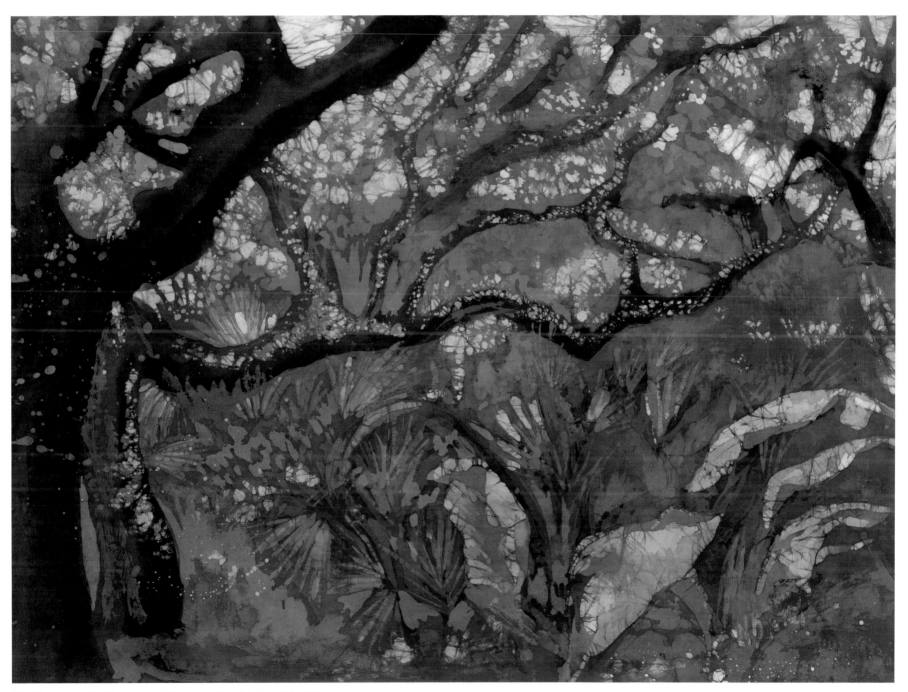

The Hammock Batik; wax and dye on cotton fabric 25 x 34"

We Love the Beach Batik; wax and dye on cotton fabric 17 x 24"

St. Augustine Lighthouse Batik; wax and dye on cotton fabric 25 x 22"

JEAN TROEMEL

Jean Troemel's business card, a bright patent-leather red, lists her profession as "Artist" in bold, gold lettering. Mentor, teacher, founder of arts organizations, tireless champion of artists and successful portraitist and landscapist, the 86 year-old Troemel is art to her many admirers.

Born in Alma, Michigan, Troemel has been a force in artistic circles in Florida for over sixty years. "I had a wonderful start with enthusiastic parents. We came down here when I was two and I spent half of each year in Florida until I went off to school. I just loved Florida, so when I married, we settled in Winter Haven and later moved to St. Augustine. As a child, looking up at the Ponce de Leon Hotel, I thought that all the faucets and door knobs in it must be made of gold, so I was thrilled when I got to live here."

Troemel was trained at the Art Students League and the National Academy of Design in New York City and paints in a variety of genres. "I was interested in architecture and loved the constantly changing light in St. Augustine and the way the areas of light and dark created shapes. I wanted to do portraits, did quite a lot of them, and then moved to landscapes. Boredom is the enemy of creativity so I've always had to do something new—even if it was the same street scene, it was different depending on the light or the time of day—I couldn't copy myself."

Trained in abstract and realistic styles, Troemel focuses on her five art elements—value, texture, shape, line work, color and mood in creating a composition. "You have to like something to paint it, that's the first thing, and the underlying shapes have to be good. Every painting, even a realistic one, has to be a good abstract painting underneath. After that, I tend to work in cycles, focusing on a particular element. Right now, I'm back into texture but I'm always after mood and the way the changing light creates shapes and values to create a mood. The mood and not the subject dictates what I paint."

These days, you'll find Troemel in her studio in the historic city. "I used to work out doors but now I work in the studio. I carry a little camera with me and when something catches my eye, I take a photo so I can look at it twice—to review what I liked about it. Then I start to paint, using my imagination to capture that initial feeling of inspiration."

In looking to the future, Troemel sees herself coming full circle. "All these years, I've gone in stages and at this point I just let it happen. I'm having fun now just seeing that I've been successful in saying what I wanted to say. I'm going along with it."

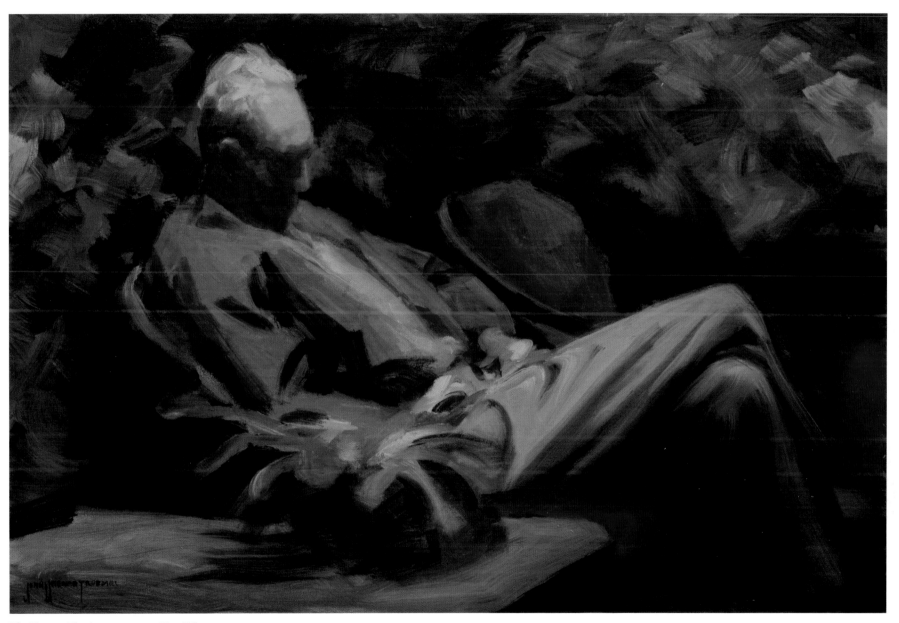

The Nap Alkyd on canvas 20 x 30"

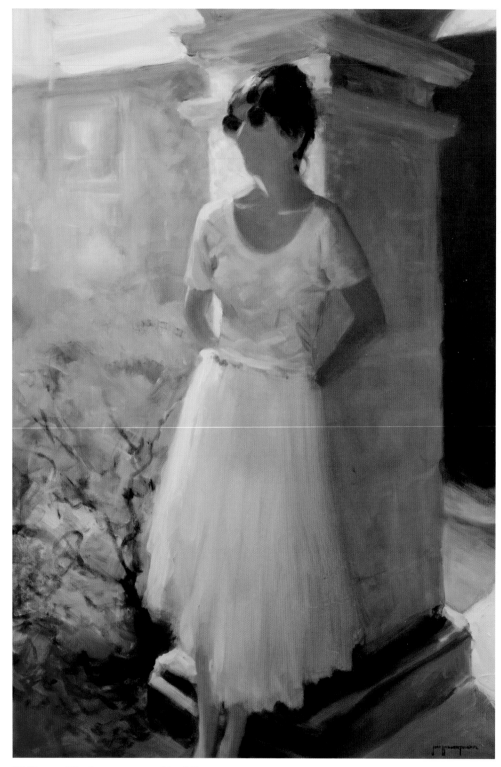

Waiting Alkyd on canvas 36 x 24"

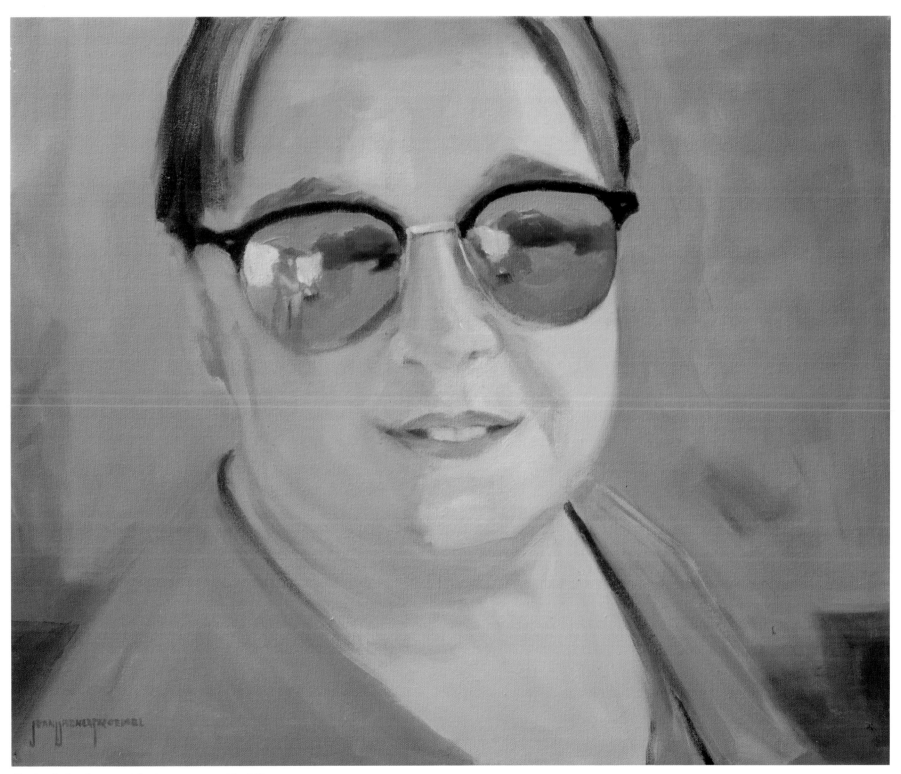

Charlene's Sunglasses Alkyd on canvas 20 x 24″

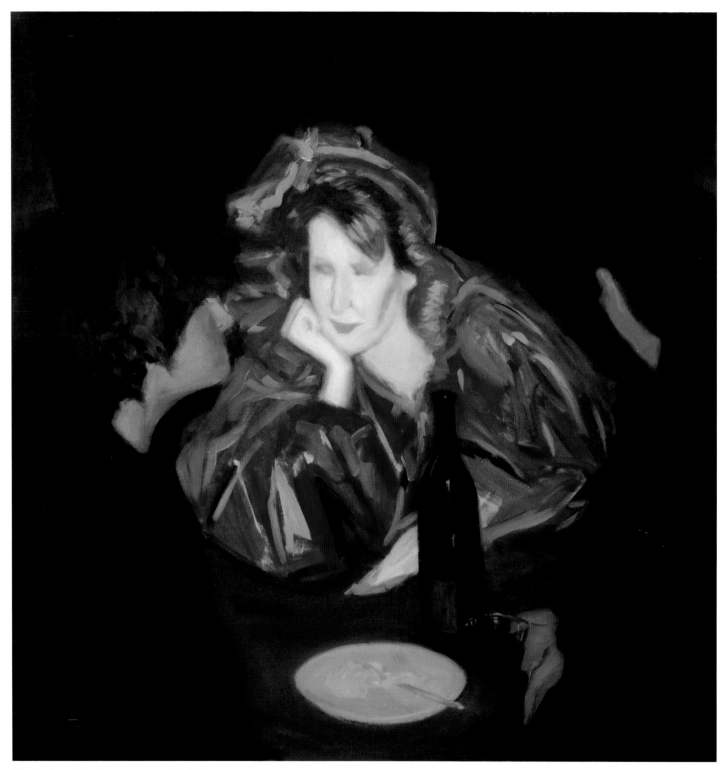

The Party Alkyd on canvas 36 x 36″

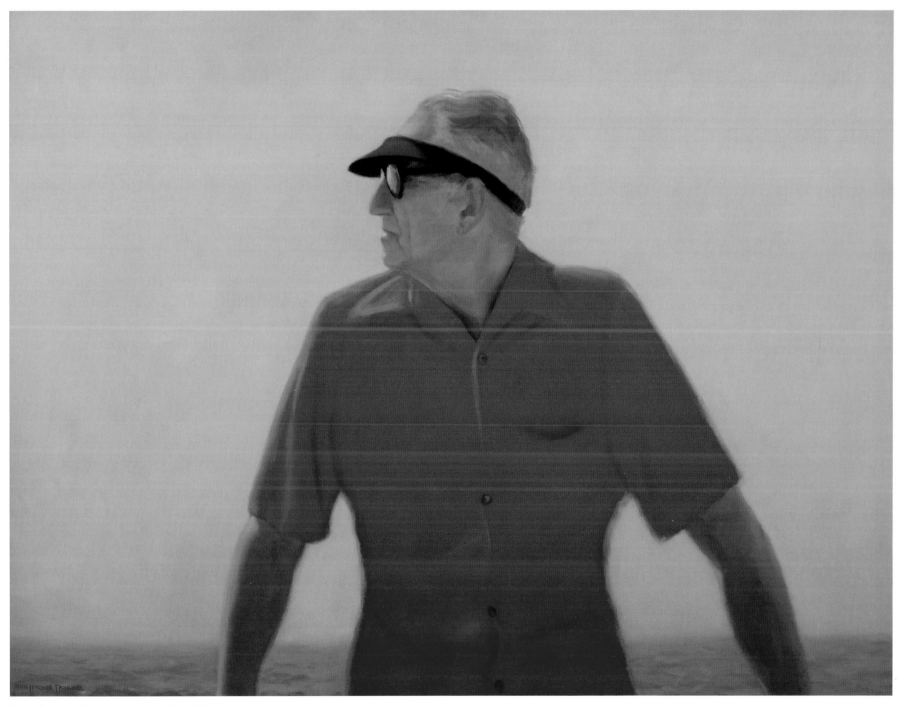

Capt. Ben Alkyd on canvas 32 x 42″

RUSS WILSON

Like many painters before him, Russ Wilson began his art career as an illustrator. With a Bachelor of Fine Arts degree from Florida State University, Wilson created work for a variety of national clients before devoting himself to his own visions of Florida, past and present. "I moved here during the summer before third grade," says Wilson, "so I feel like a native. Born in coastal California, we had been living in Little Rock, Arkansas when my Dad said, 'We're moving to Florida'—warm water, sunshine, palm trees! Like my father, I have salt water in my veins and have always felt drawn to the coast. I love the abundance of water and the sense of space in the coastal and rural areas of Florida."

Focusing on narratives and vignettes of beach architecture, Wilson's work has a timeless quality, a play of light and shadow that is reminiscent of the work of Edward Hopper and evokes the essence of the state. "I am drawn to the feeling and light of the coastal South which helps define my subject matter. I am a representational artist, but more than just representation, I want the viewer to see the abstract beauty of the forms and the play of light on the surfaces. My compositions are generally very angular and strong and I try to introduce subtle modernistic elements through color, form, and composition. I find the abstraction within the forms, merging the representational with elements of modernism. I feel that helps to give my canvases their strength, as well as convey what inspired me to paint it in the first place."

In approaching a subject—a weathered beach house, a lone fisherman in the marsh, a mid-century drive-in or storefront—Wilson works to bring the viewer into his world of narrative and possibility. "I am usually drawn to a subject by a little play of light or form that catches my eye. I reconstruct it, adding and subtracting elements and 'actors' until I have come up with a very subtle narrative. I find beauty in the commonplace scenes, and tend to shy away from the predictable expanses and sunsets. I want the viewer to take away a bit more of the feeling of being there than just a well rendered scene. I have a quote from Robert Bresson taped to my easel: 'Make visible what, without you, might never have been seen.' That is my goal; the medium is almost incidental to the message."

When asked where he sees himself in the future, Wilson quips, "Probably back down the street to the art store for a few more tubes of ultramarine!"

2nd Avenue North Oil on canvas 28 x 20″

Lifeguard Tower Pastel on paper 29 x 21"

The Late Show Oil on linen 28 x 40″

JOHN WILTON

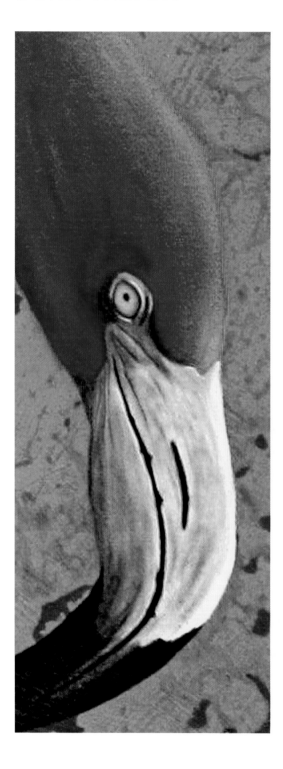

John Wilton's mixed media constructions are filled with the tropical colors of his Key West childhood. Born in his mother's home state of Maine, Wilton moved to Key West at age five and then to Homestead when he was twelve. "I cannot think of a better childhood for a young boy than the one I had in Key West," says Wilton. "I rode my bike all over the island, had my own motor boat, caught tropical fish that I sold to the aquarium and had a paper route delivering to the submarines at the navy base. When we moved, Homestead was very rural but Miami was only twenty miles to the north and the Keys were still the next destination to the south."

Surrounded by adventure and activity, Wilton also found time to nurture his artistic potential. "My father was a self-taught artist so I dabbled a little at home when I was twelve or thirteen. I showed some signs of creativity in high school and attempted to study drafting but found it too restrictive. I took a design class in junior college and upon arriving at FSU, I never left the art building. After graduation, I worked as an art director before getting a degree to teach, which provided the freedom, support and time to create the art I wanted to make."

Growing up *Down in F.L.A.* as the title of Wilton's first large series of work proclaims, gave the artist the ability to communicate his feelings about living in Florida. "I moved to Miami to attend community college and to Tallahassee for my bachelor's degree, then returned to Miami with my wife and daughter and worked there for twelve years before moving to DeLand where we have been for twenty-six years. My daughter is Florida-educated and now lives in Orlando, and I have AA, BA, MS and Ed D degrees, all from Florida schools. So, how has Florida affected my life? Florida has BEEN my life!"

Influenced by the pop artists of the 60s, Wilton uses all things Florida as source material for his visual descriptions of the experience of living in the state then and now. Merging images from mass culture with hand-painted and digital passages, Wilton replicates the sensory overload experienced in a media-driven age as he transforms the accustomed into the unusual and gives the viewer a sense of the complex visual possibilities of the everyday world. "In the eighties, I had finally reached the point where I had the time and desire to say something, along with the tools to communicate visually, so I decided I wanted to share what it is I feel about where I live. Eventually, this course evolved beyond that first series to an ongoing use of Florida as subject matter, and Florida has been the theme for most of my public art commissions as well. My art definitely leads the way, and I do my best to follow the muse."

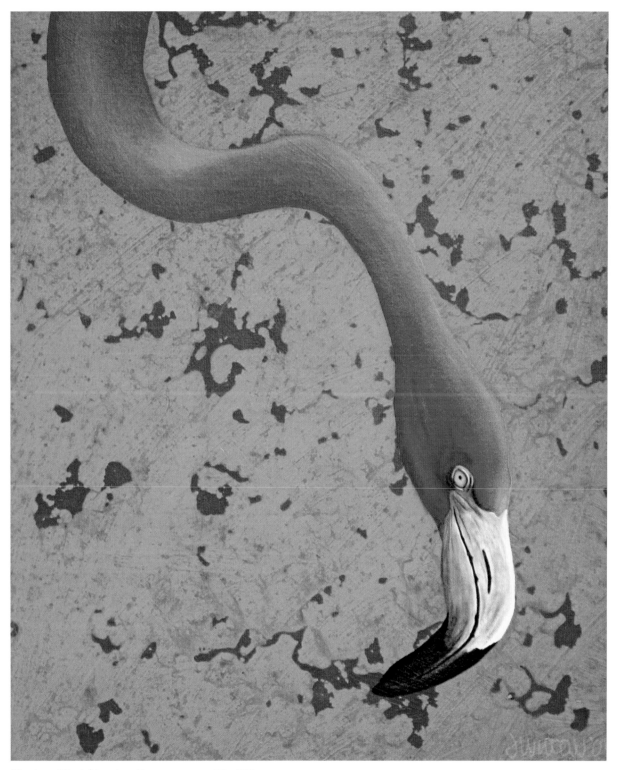

Flamingo (Stretch) Acrylic on canvas 36 x 30″

The Family Vacation Mixed media on polymer panels 48 x 60"

Searching (for the Road to Atlantis in the Philodendron Forest)
Acrylic on polymer panel 96 x 48"

FLORA AND FAUNA

Working during the day as a graphic designer, Victor Bokas spends his evenings and weekends as a painter. "I have a passion for painting and hope it shows in my work," says Bokas. "I never know where inspiration will strike."

For Bokas, inspiration usually has a Florida accent. Born in Gulf Breeze, Bokas was educated at Pensacola Junior College and at the University of Florida. "I'm a native Floridian, from the Panhandle. I've spent my whole life in the Sunshine State, so it's a given that my work has been influenced by sunbathing tourists, palm trees, fish and tropical scenery. Florida is everywhere in my work, if not literally, then in the spirit and energy of the vivid colors and bold shapes that have surrounded me all my life."

This celebration of tropical colors and subjects focuses on the natural wonders found in Florida. "My work is about nature. I'm inspired by the colors, shapes and textures of the landscape and while working at Sea World for eight years, the image of fish became more important in my compositions." Filled with complex, intertwined, undulating forms, Bokas' paintings engage the viewer, inviting entry into a joyful, animated terrain. "My work tends to be busy—I want the viewer to get lost in areas, to look at the patterns, textures, and colors, to be reminded of Florida vacations."

Vacationers arriving at the Orlando International Airport are met by one of Bokas' largest and most visible commissions. *Florida Vacation* is a 1,320 square foot floor mosaic—a playful visual signal to the start of a visit to Central Florida. "I think it's a nice surprise to get off a plane and be greeted with this bright flash of colors, the colors that represent Florida."

Versatile and multi-talented, Bokas also creates work that is more personal. "Through images of trees and Greek vases, I want viewers to realize how important family and heritage are to me. Greek images are incorporated into my work, as my heritage is something that makes me proud."

In his new series, Bokas is painting images of trees, each featuring a simple graphic created in a loose, painterly style. "The tree is symbolic of the way a person changes over time: some weather life's fiercest storms, others wither in the face of adversity. It isn't a realistic representation of nature, but rather an expression of how I feel when I'm in the presence of nature and how my abstract, emotional and geometric eye views nature—a place where the tree is a source of strength and constancy, a place where our souls are rooted. This series represents a merger of my selves: the graphic designer and the fine artist, the kitsch collector and the rustic Florida boy."

Family Trees Oil on canvas / diptych 48 x 96"

Florida Vacation Oil on canvas 36 x 48"

Grecian Vases Acrylic/collage on PVC 60½ x 48"

LOUISE FRESHMAN BROWN

Louise Freshman Brown's list of accomplishments will take your breath away. Distinguished Professor of Art and Design at the University of North Florida in Jacksonville, Freshman Brown is a painter and mixed medium artist whose works are included in over 500 public, private and corporate collections. Her solo and group exhibitions include shows at the Monique Goldstrom and Childs galleries in New York and the Jane Haslem Gallery in Washington, D.C. A presence on the international art scene, Freshman Brown's work has been exhibited at the Piirto Galleristi in Helsinki, Finland, the Galleria Vetro and Arte in Venice, Italy, and the Edsvik Konsthall in Sollentuna, Sweden.

Born in Oneida, New York, Freshman Brown moved to Florida in 1966. "I often came to Florida with my family when I was a child," says Freshman Brown, "and had wanted to live in Florida ever since. I was more than happy to move here. Later I moved to the Washington, D.C. area for a few years and then came back to Jacksonville, where I have continued to live."

Finding a home in Florida influenced Freshman Brown's artistic direction. "The light, color, ocean and natural landscape here have a prehistoric quality, and when I first arrived, I was overwhelmed by the open space and vastness of the sky. I focused on plant life, real and imaginary; plants, landscapes, marinescapes and exotic birds, combining architectural imagery with nature and still life. In everything I did, the color and environment of Florida were primary considerations."

In her current work, *Backyard Series*, Freshman Brown continues to examine her experience of living in Florida. For this body of work, the imagery was inspired by her backyard. "The series reflects an instant in Nature, contained by means of spatial relationships and shapes. I paint bamboo, fern, spiderworts with multiple thin glazes and by simplifying and eliminating. I capture the mood, heat, humidity and beauty of Florida's natural habitat."

Referencing George Inness, and James McNeill Whistler, artists whose work is subtle and monochromatic, Freshman Brown found balance in a variety of sources. "What I convey to the viewer exists on many levels. My roots are realism, abstraction and formalism and as a result, I incorporate recognizable imagery with abstraction. My work reflects, documents and comments on the time in which we live. We live in a society that pollutes and is careless about the environment. Through Florida as subject, I create work that captures and translates the environment's profound affect aroused in me and enables the viewer to witness the fragility and delicacy of the balance of nature."

Backyard Series I Acrylic and charcoal on canvas 48 x 56″

Backyard Series II Acrylic and charcoal on canvas 48 x 56″

Backyard Series IV Acrylic and charcoal on canvas 40 x 48"

Backyard Series V Acrylic and charcoal on canvas 36 x 48″

Backyard Series VI Acrylic and charcoal on canvas 36 x 48"

JOHN BUNKER

John Bunker is a champion of the arts in Northeast Florida. In 2007, Bunker received the prestigious Individual Arts Award from the Cultural Council of Greater Jacksonville in recognition of three decades of distinguished leadership in the community. A museum curator, museum director and celebrated still life artist, Bunker's name is synonymous with intellectual rigor, administrative prowess and an elegant, cerebral creativity. With numerous group and solo exhibitions to his credit, Bunker's work has been included in regional, state and national collections—public, private and corporate.

Appealing to a wide audience, Bunker's work identifies him as a native Floridian. "I've always lived in North Florida—Jacksonville particularly," says Bunker, "except for two years of graduate school in Peabody College at Vanderbilt. Florida appears in most of my work, even though the subject matter may not always reflect this. At one point I believed that my work was really about global issues, but now I understand that where you live deeply—possibly unconsciously—affects your work in many ways. Florida, the light, surroundings, the growth, the havoc, the changed environment over these sixty years, is embedded in my existence."

This personal view of Florida is reflected in Bunker's spontaneous yet studied approach to creating works of art. "I often start with recognizable imagery, and then let it grow, to become a unique statement on canvas, paper, or other surfaces. This I achieve by using many different materials, overlays, scrim type layering, especially through the introduction of metallic paints and other mediums. I wish viewers to see something different every time they look at the work. I strive to have the work appear different in various settings, various light sources—so viewers can be surprised by what they see at different times of day and night. I've found that I do retreat to studying and dealing with what I find beautiful in our environment, but depicted in a 21ˢᵗ century attitude and in what I believe is a unique way, with a unique vision."

Complex, beautiful and challenging, Bunker's unique still lifes of shells, flowers and fish are metaphors for his elegant approach to painting and his constantly evolving life and work. "I wish to create a complex, visual puzzle that is beautiful and mind-expanding. I work towards this complexity through a planned format, with simplicity growing into complexity. I want viewers to be challenged, as I have been. I've always believed that a painting, once gone from the creator, is a completely different thing. It belongs to the viewers, who bring their own experiences to it."

Quadrant Light to Dark Watermedia on paper board 40 x 32″

Gilded Hydrangea II Watercolor and metallic gouache on paper 30 x 24"

Les Roses Watercolor on paper 30 x 40"

MAURY HURT

There aren't many artists who can say that they have been presented with the key to a city like Orlando or hold a baseball record at a state university, but painter Maury Hurt counts both of these among his many accomplishments. Born in Orlando and educated at the University of Florida in Gainesville, Hurt has always lived in the state, using his experiences here as springboards for his creativity. "I spent my boyhood in Orlando when it was still a small citrus town," comments Hurt, "It provided a wonderful environment for swimming, fishing, hunting and exploring. Since I have always been enthralled by the natural beauty of Florida, it became natural to want to convey how I felt in my painting. When I later learned about the history and prehistoric aspects of Florida, they became subjects in some of my paintings as well."

Graduating from UF with a degree in art, Hurt first worked as a graphic designer but soon focused on his own art and became a full-time painter. Setting up a studio in Maitland, Hurt became an influential teacher and mentor, a widely known and celebrated figure in Central Florida artistic circles. "Art has always been the best way I have had to express myself. It's stimulating and wonderful, and I feel fortunate to be able to have a thought and then find some form to communicate the thought."

Whether working on landscapes, figurative paintings, surrealistic dreamscapes or still lifes, Hurt's thoughts are never far from Florida icons like hurricanes, panama hats, and palm trees, and he uses color choices and compositional decisions to evoke the atmosphere of favorite locations like the Florida Keys and his native central part of the state. "Sometimes I focus on the mid-tropical summer of Central Florida and the fruit, vegetation, shells, flowers, old glass and weather conditions one might encounter during the course of one of these summer days. Other times, I'll use an aqua-green color running horizontally through a composition as a symbol of the Florida Keys or create a sensation of moving shadows in a painting by softening and blurring edges."

Long-regarded as a visionary and serious artistic force, Hurt's work is widely held in public and private collections and is respected for his articulate approach. "Works of art are primarily experienced on a feeling or emotional level and as a painter, I focus my attention first on defining the specific mood I wish to convey. My next concern becomes to construct the appropriate composition that best manifests the mood in order to convey it to the viewer. When people look at my work, I want my work to tell them what kind of a person I was in my life and what I was interested in. As I move towards the future, I hope to move to more sublime and profound works, whatever they may be."

The Ospreys' Nest Watercolor 9 x 12"

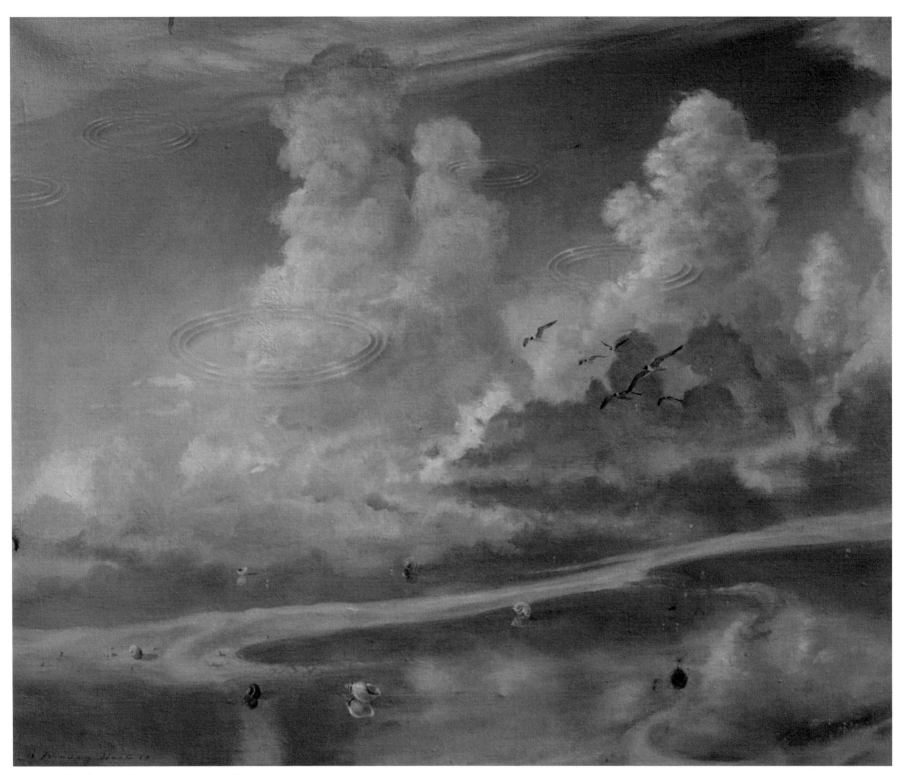

Approach of Isadora Oil on canvas 30 x 40"

The Vaca Cutbridge Oil on canvas 28 x 36″

Key Green Oil on canvas 16 x 20"

GRETCHEN LOTZ

Organic and mysterious, Gretchen Lotz's unique marble and bronze garden sculptures seem to be artifacts from an ancient world of spiraling forms and mythical reality. "I've always liked symbols and images," says Lotz. "After studying literature and working as an English teacher, the written images became visual and demanded to be born. My task was to give them corporeal form. Alone and on my own, I struggled to recreate the pictures in my head. Hundreds of sculptures later, they have distilled themselves to the spiral—coil of transcendence, each piece becoming imbued with my own personal attitude toward form. These pieces were always unexplained and they remain a mystery to me."

Raised in Miami, Lotz is an almost life-long resident of Florida. Educated at the University of Florida, she settled in the Orlando area with her husband Steve in the late sixties and began sculpting professionally in 1972. Since then, her work has been exhibited widely and is included in local and national collections. Lotz has received public commissions, most notably a sculpture for the City of Orlando's Leu Botanical Gardens, and has created a sculpture garden in downtown Orlando. In all of this work, Lotz has parlayed her love of the land into her art, developing functional yet fanciful pieces, like her shell chair, which Lotz refers to as a "comfortable connection with art."

"The imagery which I sculpt is a fantasy response to living in Florida. How could my work be otherwise? Growing up in Florida, I was influenced by my steamy primordial 'Garden of Eden' environment. My sculptures and outdoor furniture are especially created for gardens, atria and parks. They can be designed to have water flow through them, or they can be placed in an aesthetic relation to water, unplumbed. The imagery with which I work—the fish, the turtles, the frogs, the birds, the shells—all give homage to Florida's abundant water life. I am interested in creating a serene and friendly tropical bestiary which celebrates the nature of Florida."

Referencing Florida's environment as they do, Lotz's forms are tactile, sensual and inviting to human touch—a reflection, perhaps, of her long-time work with visually impaired students in the Orlando area. "I like to think that my pieces are symbols of my undiscovered self. I use organic, baroque, undulating forms. I would like to consider my work feminine and sensuous, and strong enough to be enjoyed without explanation."

Time in the Sun Mixed media collage on unstretched canvas 60 x 42″

Harvest Mixed media collage on unstretched canvas 60 x 42″

Star Gazing Mixed media collage on unstretched canvas 60 x 42"

JASON IZUMI

Most artists set winning a "best in show" award as a life's goal but for Jason Izumi, it is a regular occurrence. With compositions that combine drawing, painting, photography, collage and found objects, Izumi is a rising star on the art scene, one who has established himself to be a collector of accolades and commissions in his career as a mixed media artist.

Growing up in a rural area of Hawaii, Izumi did not spend a great deal of his youth in artistic pursuits. Moving from Hawaii to Maine, Izumi worked for the post office but traveled to Boston, Philadelphia, New York and Washington, where visits to museums changed his perspective and set him on a career as an artist. "I wasn't looking for art," says Izumi, "but museums fascinated me and I became interested in creating my own artwork." Finding early success with his paintings, Izumi attended Pratt Institute and Columbia University in New York City, graduating with a degree in art history.

Izumi returned to Hawaii, entered juried competitions and moved to Florida to participate in seasonal art festivals. "I found Florida to be nurturing to my art and I noticed that a lot of the artists there were creating avant garde and innovative pieces." After marrying a Floridian, Izumi returned to the state often, finding inspiration for his creations on each visit. "I find that I am inspired by the wilderness environment in Florida. My work takes a lot of thought, and in secluded areas, I can get in tune with the spirit I find there to meditate and concentrate."

Izumi creates compositions that are full of symbolic meaning. "I try to create an evocative world that invites philosophical contemplation in the mind of the viewer. I use elements of realism, abstraction, geometry and architecture, and reference art history, philosophy and religious symbolism. I use a lot of objects—things that I find in the street, plants, seeds, roots that I incorporate into my work. I like to vary the media, using oil, acrylic, pastel, charcoal, spackling, caulk and newspaper clippings. I use all processes and techniques, to feel free to express any and all ideas rather than limiting myself."

In working on a painting, Izumi uses his spiritual life as his starting point. "I like to relate my work to biblical prophecy, and what inspires me in prayer, to create a meaningful message for myself and for others. I try to relate scripture to what is happening to me, to see what kind of images come into my mind. Whatever I feel strongly about, I like to portray in the work. It is not always easy to do but I try to pursue this goal—to present these ideas visually, in a visual language, to speak to other people. I never see an end to what I am doing. There is so much more to pursue and to discover."

A Slice of Summer Oil on canvas 32 x 46″

Double Spiral Icon Bronze and marble 34 x 19 x 10"

Large Nautilus Bronze and marble 26 x 16 x 18"

Anniversary Spiral Bronze 27 x 23½ x 14″

STEVE LOTZ

With works in corporate collections and installations at airports, libraries and hotels, Steve Lotz has specialized in the creation of large scale paintings for public places, oversized environments that glow with energetic color, movement and light. Dynamic, organic and spiritual, the compositions evoke mystical gardens, ocean dreams and metaphorical journeys through the underworld of the soul. "The initial impulses for many of my paintings have been dreams or Active Imagination experiences. I consider the images to be a manifestation of an eternal part of Self, of the internal cosmos. They may be seen with our daytime eyes, but they must be understood with a third, or inner eye."

Raised in California, Lotz has lived in Florida for over forty years. "I came to Gainesville to begin work on the MFA degree, choosing the University of Florida because I had a high opinion of Hiram Williams. After marrying Gretchen, we lived in Jacksonville before moving to Orlando where I have spent my academic career as a professor of art at the University of Central Florida. We have lived here on the shore of a small but lovely lake. I have always felt Florida has many environmentally beautiful parts and the multicultural richness of the state encourages my hope."

With Lotz's visionary approach to painting, the influence of the Florida environment on his art has been oblique. "Although my work has always included descriptive symbols (usually of figures and nature-based forms) I don't consider myself to be a traditional realist of landscapes or figures. For the past four-plus decades my art has resulted from my efforts to understand and/or celebrate the spiritual and eternal realities that are behind the surfaces of everything. For myself, and for viewers, I have always been interested in creating symbols that honor the eternal aspects of space, matter, and persons. Even when I have drawn or painted portraits, I have never described them as being inside particular rooms or landscapes. I have wanted the presence of the individual's spiritual uniqueness to be suggested by the colors and surfaces which surround him/her."

This free-association of imagery and form has been the result of Lotz's spiritual quest. "For the past four-plus decades, my art has resulted from my efforts to understand and celebrate the spiritual/eternal realities that are behind the surfaces of everything. My life-threatening accident six months ago has confirmed in me these realities, and it has confirmed in me the conviction that my art has been consistently devoted to these realities. I now see that my intellect, ego, and consciousness have only been surface elements of the deeper me. I feel that my life and my art have been directed by powers in me that were unconscious. I have faith in the Eternal source of those powers. I pray that my physical health will permit me to seriously continue making art for the rest of my life."

Garden of Proteus Acrylic and oil on canvas 80 x 70"

Florida Garden Icon Acrylic and oil on canvas 70 x 80"

Floida Floral Icon Acrylic on canvas 72 x 58″

To create her lacy, elegant and meticulous compositions, Suzanne Wagner Magee examines blooms over the course of their life cycle. "I'll take photos of a flower over a three or four day period," says Magee, "witnessing its genesis and life stages. There's a real sense of intimacy that develops during this period and I am inspired by the intricacy and beauty of God's creation. Two flowers seem to be identical at first glance, but end up being as individual as people with variations in color, structure and the way they reflect and absorb light."

Interested in art at a young age, Magee was born in Reading, Pennsylvania, attended nursing school in Philadelphia and worked in hospitals in Pennsylvania, New Jersey and Miami before arriving in Jacksonville twenty-eight years ago. "As a child, I went to museums and took art classes, but it wasn't until I moved to Florida that I started working professionally and not just for myself." Completing a Bachelor of Fine Arts degree at the University of North Florida, Magee soon focused on the creation of botanical drawings and paintings. "Living in Florida, botanicals became a stimulus for subject matter. If I had stayed up north, I'd probably be painting landscapes with winter silhouettes of trees, but in Florida, the brilliant colors and the animate quality of the organic forms captivated me."

The process of painting is a deeply personal one for Magee. "I see something that inspires me and feel compelled to capture it on paper. It's not just a representational view of an object, but a problem-solving process, finding the best way to get to a solution." In creating a composition, Magee begins with a complex drawing that serves as an architectural framework for the layers of value that are next added. Working in watercolor, Magee creates a deep, rich surface, manipulating the medium as if it were acrylic. "I'll work in grey and ochre to form an underpainting for the piece, getting the depth that I need before adding the color."

Always striving to expand her range, Magee seeks to regenerate her muse and find novel approaches to her work. "With the botanical paintings, I always know what the end product will be and I enjoy seeing if I can measure up to the challenge presented. My more recent paintings, still lifes and abstracts on wooden boxes, are more playful, less process oriented. It's a departure for me and will help me continue to grow."

Poppy for Ann Watercolor 6 x 9"

Red Passion Flower Watercolor 6 x 9"